4/12/11

POSTCARD HISTORY SERIES

Berlin

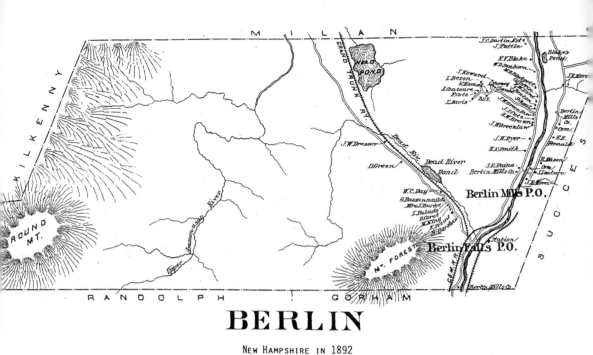

BERLIN

NEW HAMPSHIRE IN 1892
Saco Valley Printing, Fryeburg, ME 04037

This 1892 map shows the two distinctive parts of the town of Berlin: Berlin Mills and Berlin Falls, each with its own post office. The Berlin Mills Post Office was closed when Berlin became a city in 1897. The distinctive Y shape of the valley formed by the Dead and Androscoggin Rivers can also be seen.

On the front cover: This postcard is from the archives of the Moffett House Museum. It shows the direct correlation between the Androscoggin River and the city of Berlin. (Courtesy Berlin and Coös County Historical Society.)

On the back cover: See page 32 for more information. (Courtesy Berlin and Coös County Historical Society.)

POSTCARD HISTORY SERIES

Berlin

Jacklyn T. Nadeau

ARCADIA
PUBLISHING

Published by Arcadia Publishing
Charleston SC, Chicago IL, Portsmouth NH, San Francisco CA

Printed in the United States of America

Library of Congress Catalog Card Number: 2008922777

For all general information contact Arcadia Publishing at:
Telephone 843-853-2070
Fax 843-853-0044
E-mail sales@arcadiapublishing.com
For customer service and orders:
Toll-Free 1-888-313-2665

Visit us on the Internet at www.arcadiapublishing.com

With its rural feel, this postcard gives the recipient an idea of the condition of the roads to Berlin, the northernmost city in New Hampshire. This was one of the reasons for the popularity of the railroad at the beginning of the 20th century.

CONTENTS

ACKNOWLEDGMENTS

This project is a cooperative effort of several members of the Berlin and Coös County Historical Society, which I was pleased to spearhead. Although the majority of the postcard choices and captions were my own, this book could not have been completed without significant help. From ideas for chapters to the loan of postcards and from proofreading to sometimes major editing, a core group of volunteers enthusiastically stood behind this project.

Thanks go to Medora Snigger, Odette Leclerc, and Raymond Daigle, who proofread and provided the first edit of this book. Thanks also to Robert and Doris Treamer and Daigle, who provided several postcards from their private collections. I would especially like to thank Daigle for his expertise on the mills and Snigger for her knowledge of the logging camps. Invaluable research assistance was given by Leclerc, to whom no detail is too small.

Major sources of information about Berlin came from *Berlin, New Hampshire Centennial, 1829–1929* and *History of Coos County*. These and other sources, such as newspaper clippings, pamphlets, and booklets, were all found at the Moffett House Museum and Genealogy Center. Thanks are also extended to the Berlin Public Library for access to very old newspapers on microfilm.

Unless otherwise indicated, all images are from the collection belonging to the Berlin and Coös County Historical Society housed at the Moffett House Museum and Genealogy Center.

INTRODUCTION

Originally granted by the king of England through Colonial governor John Wentworth in 1771 to Sir William Mayne and others, Maynesborough remained unsettled for 50 years. Camps were built along the edge of the Androscoggin River for cutting elm trees to make potash and for hunting, but a permanent homestead was not constructed until around 1823 when William Sessions and his nephew Cyrus Wheeler erected a log cabin and cleared land for a farm. The location of this important site is on the east side of the river in the vicinity of the Maynesborough Industrial Park. Sessions spent most of his life creating farms and selling them, a real estate concept known today as flipping. It was not long before he sold this farm to his brother-in-law Benjamin Thompson. It was known as the Thompson farm for many years after Sessions sold it. The front section of the smaller barn on this site was original to this farm and was built around 1850.

In 1829, the seven families living in Maynesborough petitioned the state for incorporation. The petition was granted, and the town of Berlin was incorporated that same year. Just why this name was chosen has been lost to history, although it was the fashion at the time to use world names; for instance, in Maine, the towns of Paris, Norway, Peru, and Mexico, and others can be found. Some say the decision was influenced by a settler with relatives in Berlin, Connecticut.

The Thompson farm was later bought by Brown Company as a place for its workhorses to recover from injuries and for use as its summer residence in the off season, as logging was primarily done in the winter. In 1947, the larger barn was moved next to the smaller barn from the other side of Horne Brook behind what is now White Mountain Chalet. This barn was part of the Maynesborough farm, an Arabian horse–stud farm owned by William Robinson Brown, a co-owner of Brown Company. He and his family summered here from their home at 250 Church Street in Berlin, which still stands. When it was no longer used by the company, the house at Thompson farm was burned as part of a training drill by the Berlin Fire Department in the early 1970s. These two barns, along with about three acres of land, are now owned by the Berlin and Coös County Historical Society.

The sudden, rapid growth of Berlin can be traced directly to the power held in the Androscoggin River that bisects the city. Such was the power of the river that its full potential was not realized until the advent of the turbine. Waterwheels would not survive the spring freshets. The coming of the railroad in 1853 also brought with it out-of-town investors. Hezekiah Winslow and his partners from Portland erected a sawmill at the northern end of Berlin on the west bank of the Androscoggin River where Northern Forest Heritage Park now stands. That year, they also built a boardinghouse across the street from the sawmill to house workers and a company store. This house still stands and is the oldest residence in Berlin, now known as the Brown Company

House. For many years in the 20th century, it was the home of the superintendent of the Brown Company Mills in Berlin and Gorham.

The name of the sawmill was changed from Winslow Mill to Berlin Mills in 1866, after Winslow sold his share. In 1868, William Wentworth Brown of Portland became a partner in this mill. He established a head office in Portland and a wharf there for shipping the lumber. Brown bought controlling interest in the mill in 1888 and sent his son Herbert J. Brown to Berlin as superintendent. He was the first of the Brown sons to live in Berlin, which was something his father never did, choosing instead to oversee the business from Portland. Herbert J.'s house, next to his brother William Robinson's, still stands.

Although the sawmill was large by any standard, it was pulp that built Berlin to new heights. In 1877, Henry Hart Furbish established the first pulp mill in Berlin, the Forest Fibre Company. He is considered the true "father of Berlin." It remained for less than 20 years and was overshadowed by the Burgess Sulphite Mill, as the sulphur process introduced by the Brown family superseded the soda process employed by Furbish. With the addition of the Riverside Pulp Mill, Electrochemical Plant, Tube Mill, expansion at Cascade in Gorham and LaTuque in the province of Quebec in Canada, Brown Company became a world force as the Brown Corporation. In the 1920s, the largest papermaking complex in the world was in Berlin and Gorham. Orton Bishop Brown, who was put in charge of the mills in Berlin and Gorham by his father, William Wentworth, had a beautiful large house complete with a ballroom and a grand staircase on the corner of Church Street and Hillside Avenue. It was torn down in the early 1970s. Elderly housing now stands in its place.

The Browns were certainly a major influence in the community as they and their families took an active interest in Berlin's citizens, their work force. Whatever improved the family helped their workers, whose nationalities included Syrian, Italian, German, Russian, Norwegian, Swedish, and, foremost among these, French-Canadian. The Brown family hired visiting nurses, established the first kindergarten, and donated books written in Norwegian for a library at the St. Paul Lutheran Church. Of the three churches in Berlin on the National Register of Historic Places, one is the Russian Orthodox church. Also, the Nansen Ski Club is the oldest ski club in the United States still in existence.

Berlin was incorporated as a city in February 1897. It reached its peak in number of inhabitants, over 20,000, in the 1920s. After that, the closing of the International Paper Company mill, the Depression, and World War II, when workers were drafted or left for work in the aircraft plants, all lead to the emigration of families. GIs returning from the war did not make up the difference, although the baby boom did increase the number of students in the schools. Berlin High School graduated about 350 seniors in 1973; today the class numbers around 120. College graduates rarely return home. The closing of the Berlin mills in 2006 has been a hardship to the city that now numbers about 10,000 citizens. The mill in Cascade is limping along for now, but the future is not bright.

After 130 years of being a mill town, Berlin finds itself at a crossroads. The only thing certain in life is change, and this is especially true here. What the future will bring is uncertain, but it already has no resemblance to the Berlin of everyone's memory, as all but three mill buildings were torn down in 2007. Only one idle smokestack remains to remind visitors of the skyline that was once so distinctive in this region.

One

INDUSTRIALIZATION
OF THE VALLEY

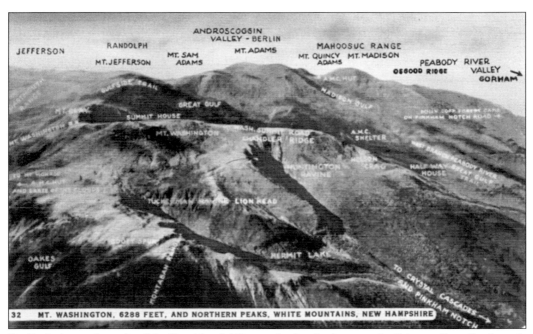

Berlin is situated north of the Presidential Range in the Androscoggin River valley. Gorham is south and downstream on this same river. The Peabody River parallels Route 16 and flows into the Androscoggin River from its source in the Presidential Range, which is within the White Mountain National Forest.

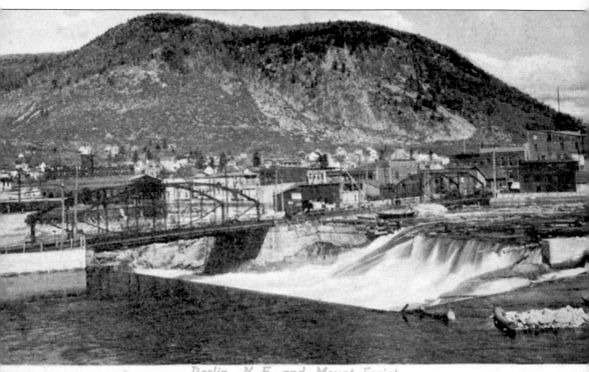

Berlin, N. H. and Mount Forist.

Berlin is situated in a valley surrounded by Cates Hill, Mount Jasper, Enman Hill, and 2,046-foot Mount Forist, named for pioneer Merrill Forist. It was originally known as Plumer's Fort in honor of New Hampshire governor William Plumer, who served from 1812 to 1813 and 1816 to 1819. He was also the first president of the New Hampshire Historical Society. First through Sixth Avenues are at the foot of this mountain.

1319 -BERLIN. N. H. FROM CATES HILL

Mount Forist is the most noticeable geographical feature in the city. Its sheer rock face has attracted some casual climbers who sometimes find themselves stranded and needing to be rescued. It is not widely renowned for rock climbing. Children refer to it as the "elephant mountain" because its outline resembles the animal.

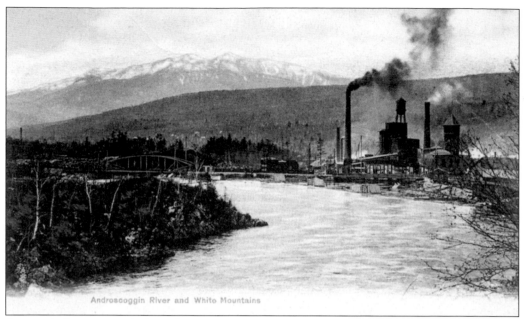

Androscoggin River and White Mountains

Despite its location in the heavily visited White Mountains and its proximity to the Presidential Range, Berlin never really was a tourist mecca. Some folks came to see the Berlin Falls and a small hotel was built near the Alpine Cascades that flow into the Androscoggin River, but it was the power of the river that attracted industrialists with its untapped potential. (Courtesy Raymond Daigle.)

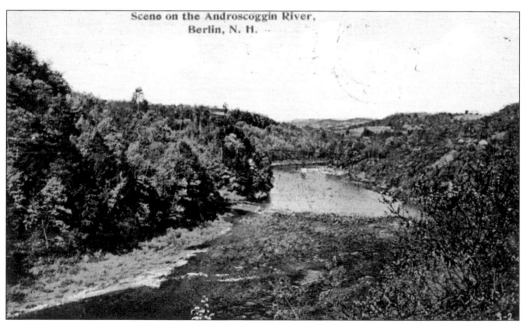

Scene on the Androscoggin River, Berlin, N. H.

The Androscoggin River is formed in Errol, where the waters of the Magalloway River and the outflow from Lake Umbagog meet. From Errol, it flows 170 miles into Merrymeeting Bay at Brunswick, Maine, where it is joined by the Kennebec River. From there, the combined waters flow into the Atlantic Ocean at Bath, Maine. (Courtesy Raymond Daigle.)

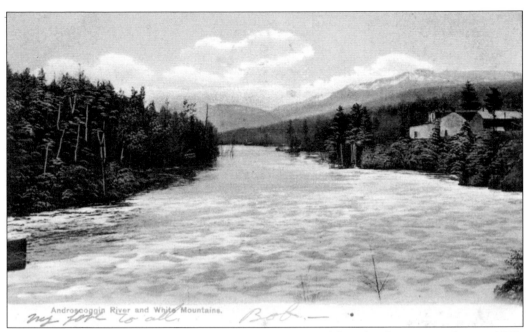

Androscoggin River and White Mountains.

my pork to all. Bob.

Waterpower and timber are the two resources that attracted farsighted men to Berlin. In 1870, Berlin had a population of 529 who labored at a number of small sawmills, a shingle mill, and a gristmill. Here was plenty of raw material and the power to process it. Power generated by this flow ran the power plants of Berlin Mills Company and International Paper Company.

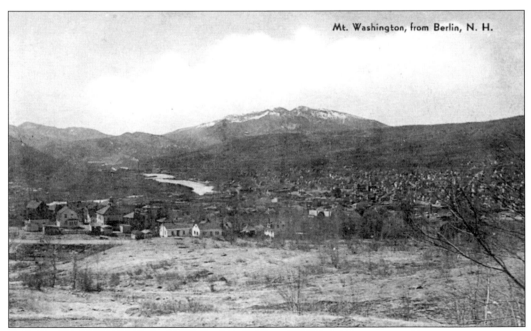

Mt. Washington, from Berlin, N. H.

In addition to the mills, power is contributed to the grid. The first dams upriver control water flow, maintaining a constant 1,600 cubic feet of water per second year-round. The river in Berlin drops 300 feet within two miles. The waterpower of the Androscoggin River has undergone continual development, and it now represents the most completely regulated flow in the state.

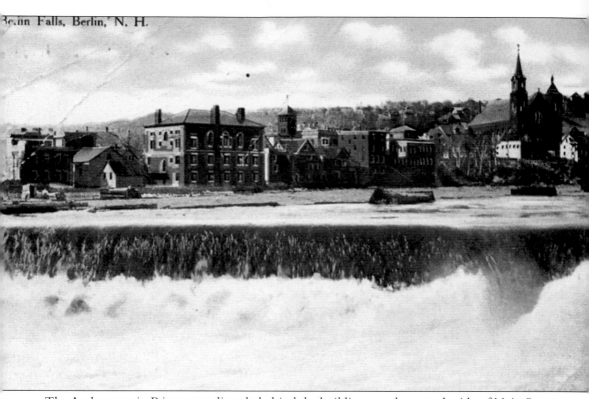

The Androscoggin River runs directly behind the buildings on the easterly side of Main Street in the downtown district. The large brick building in the center is the courthouse. The tower is part of the Central Fire Station and is used for drying hoses. The next short tower is part of the home of Henry Hart Furbish. And finally, St. Anne Roman Catholic Church can be seen farthest right.

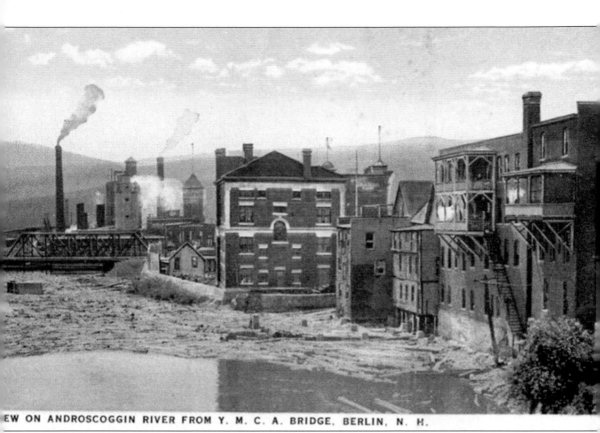

This same area is seen looking south with the courthouse again in the middle. The logs in the river have gone passed the Berlin Mills Company and are headed for International Paper Company, which can be seen in the distance. This dates the postcard to before 1930 when the mill was closed. (Courtesy Raymond Daigle.)

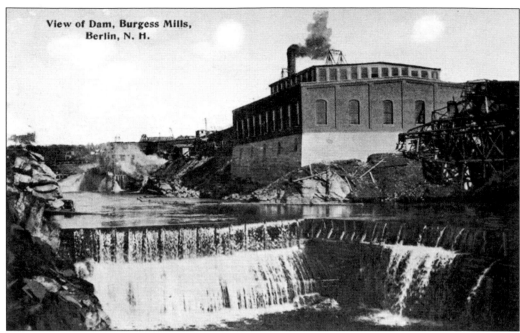

View of Dam, Burgess Mills, Berlin, N. H.

There are five dams on the river within the Berlin city limits, the last being exactly on the town line with Gorham. All are still in operation. The first to be built was the Sawmill Dam, located at the "head of the falls" in the northern part of Berlin at the site of the Hezekiah Winslow sawmill. This was later bought out by William Wentworth Brown and was the start of his immense holdings. The next dam downriver is the Riverside Dam (above), used to power the mills of the Brown Company. This dam is now visible to the community after the demolition of the mills. It was located within the mill complex and was rebuilt around 1920 with wooden penstocks directing water to a powerhouse at the foot of Success Street, seen below. These wooden penstocks were replaced in 2007.

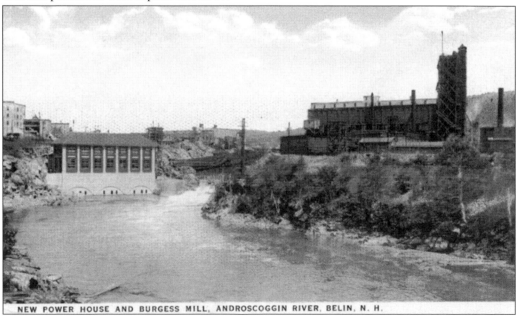

NEW POWER HOUSE AND BURGESS MILL, ANDROSCOGGIN RIVER, BELIN, N. H.

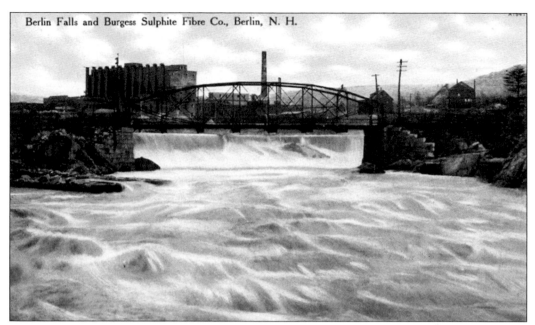

Berlin Falls and Burgess Sulphite Fibre Co., Berlin, N. H.

The next dam downriver now belongs to Public Service of New Hampshire and is part of the T. Brodie Smith Hydro–Electric Station. It is situated adjacent to the Mason Street bridges, with the power plant south of downtown. This dam was originally built to power the Glen Manufacturing Company mills and then International Paper Company.

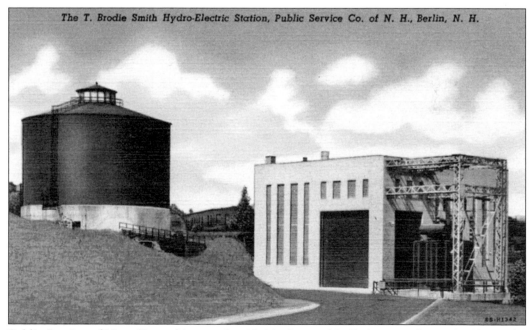

The T. Brodie Smith Hydro-Electric Station, Public Service Co. of N. H., Berlin, N. H.

Public Service of New Hampshire purchased this dam and built its powerhouse in 1947. The dynamo was replaced in 2006. Other modern updates were added or installed in 2007. A scenic river walk was built by the company on the site of the former International Paper Company mill. Its southerly entrance takes one up the driveway seen here and beyond the surge tank.

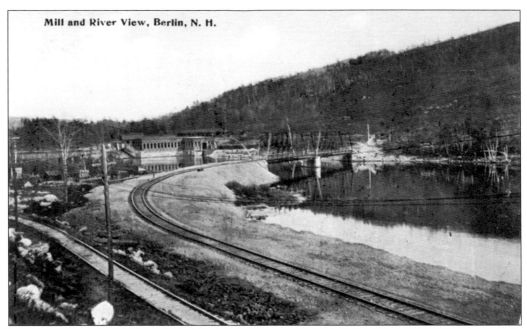

Mill and River View, Berlin, N. H.

The fourth dam is the Cross Dam. Located adjacent to Watson Street off Glen Avenue, it was built in 1904 by the river superintendent for Berlin Mills Company, Charles Sanborn. The land for this dam was cleared at the same time as the land for the Cascade Dam. The railroad tracks on the right connect the Cascade mill with Berlin Mills.

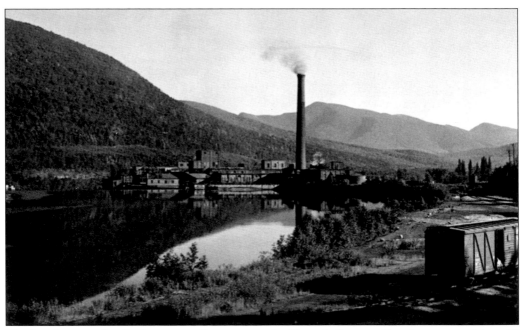

The last dam, on the Gorham town line, powers the Cascade Paper mill and was part of the mill complex of the Brown Company. The Cascade mill is the last remaining paper mill in the area. Now owned by Fraser Papers, it no longer relies on the pulp produced in the Berlin mills but must buy it from outside sources. The pond formed by the dam can be seen clearly here.

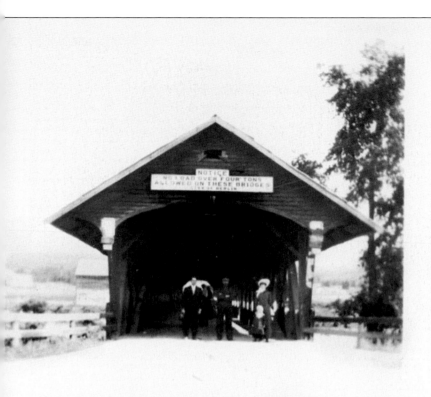

The first bridge to span the Androscoggin River was built in the winter of 1851–1852 in the northern section of the town beyond the road up Cates Hill. This bridge was washed away around 1855. The Sam Paine covered bridge, so-called because it was located across the road from his farm, was built about one mile downstream in the winter of 1857–1858 and torn down in 1916 after the Berlin Mills bridge was built closer to the city, just above the Sawmill Dam. This latter bridge gave more direct access to the homes and the mill on the east side of the river in the northern part of the city. The Twelfth Street bridge was built in 1975 at the same location as the former covered bridge. This bridge derives its name from the street that continues across the river from the west to the east side. With the opening of this bridge, the Berlin Mills bridge became a pedestrian walkway in December 1979. (Courtesy Robert and Doris Treamer.)

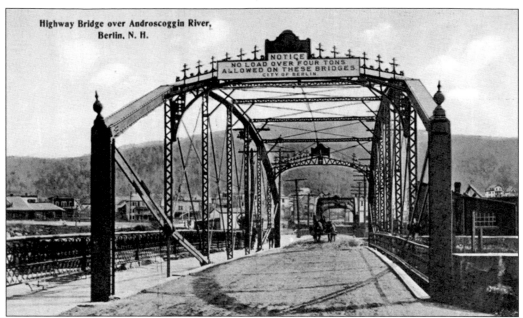

Highway Bridge over Androscoggin River, Berlin, N. H.

NOTICE
NO LOAD OVER FOUR TONS ALLOWED ON THESE BRIDGES.
CITY OF BERLIN.

The bridges that had the most impact on the development of Berlin were the Mason Street bridges, which are located in the downtown area. They extend Mason Street to the East Side where the road becomes East Mason Street. They provide access to Tondreau Peninsula, which lies mid-river and is named for former mayor Aime Tondreau, who lived in the East Side. This peninsula was once the site of part of the International Paper Company mill and now features the previously mentioned river walk. First built in 1892, the iron bridge (above) was replaced in 1907 with a steel bridge (below) similar to the Berlin Mills bridge. This view is from the East Side looking west toward Main Street. The twin Morin blocks are directly ahead. The Albert Theatre can be seen on the right. Open-deck bridges replaced these steel bridges in 1965. (Courtesy Raymond Daigle.)

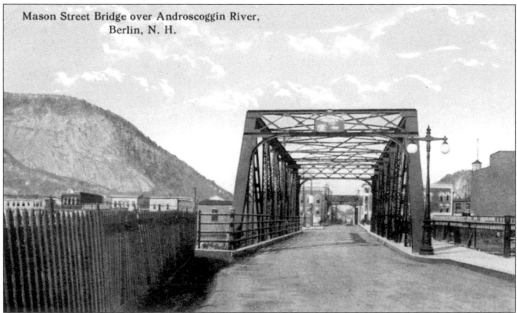

Mason Street Bridge over Androscoggin River, Berlin, N. H.

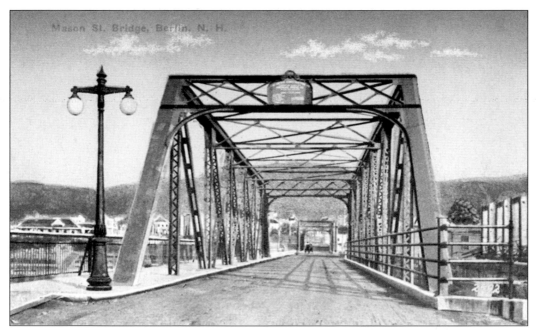

The Mason Street bridge, looking east, opened up the East Side of the city to development. This was the fastest growing part of the city once the bridge was built. The station for the Boston and Maine Railroad can be seen to the far left. The end of the line for this railway was within the mill complex.

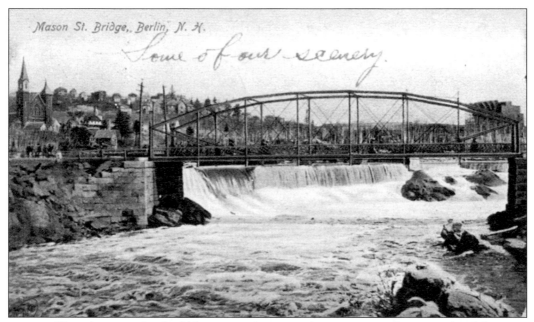

Many mill workers opted to build homes on the East Side, as it was on the same side of the river as the new mills, and therefore, they could walk to work more easily. Few people had their own means of transportation then, hence the popularity of corner markets and the trolley. (Courtesy Raymond Daigle.)

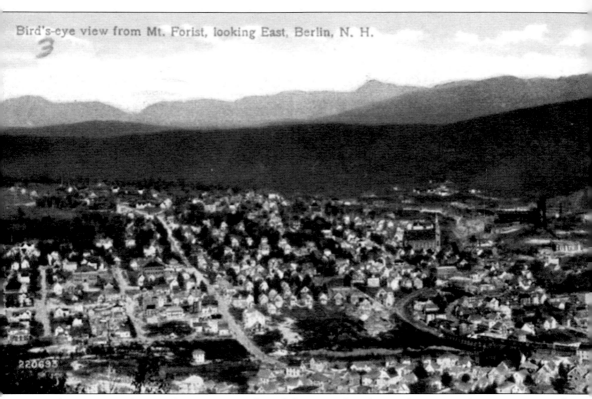

Bird's-eye view from Mt. Forist, looking East, Berlin, N. H.

These postcards give the viewer an idea of the size of Berlin in the very early 1900s. Most of the population at that time was found on the west side of the Androscoggin River as the Mason Street bridges had just been built. In 1909, the city created Ward IV for the new East Side residents. The most distant mountains are part of the Mahoosuc Range on the Maine–New Hampshire border. The tallest seen is Goose-Eye Mountain, which stands 3,870 feet. The East Side of Berlin was just beginning to develop at this time. It became almost self-sufficient, with its own pharmacy, grocery store, dentists, doctor, funeral parlor, Catholic church and school, fire station, public elementary school, dry cleaner, and so on. The main streets in this part of the city are named for the 10 counties of the state: Belknap, Carroll, Cheshire, Hillsborough, Merrimack, Rockingham, Stafford, and Sullivan running south–north. Coös and Grafton are the main west–east streets and are parallel to each other just one block apart.

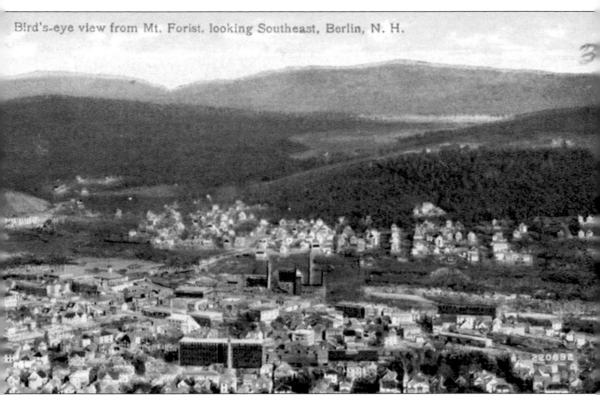

The farms above the east side are on Enman Hill with Mount Carberry in the background. Primarily of French-Canadian descent, the residents of this section of the city were content to keep to themselves and thus kept their language and customs longer than the French-Canadians elsewhere where they commingled more with other ethnicities. The first cross street, Goebel Street, was so named because of the small group of German immigrants that resided here. At one time, it was known as Germantown. The population of the East Side is more diverse now, but still predominantly French-Canadian. The small enclave of Napert Village was totally enclosed by Berlin Mills Company. Hutchins Street, the major route connecting the northern and southern sections of the East Side, once wended its way through the village but now bypasses it. The village is half its former size; many houses having been bought by the mill and torn down. The East Side is no longer self-sufficient, having lost many of its services, such as dentists, doctor, funeral parlor, grocery store, pharmacy, schools, and more.

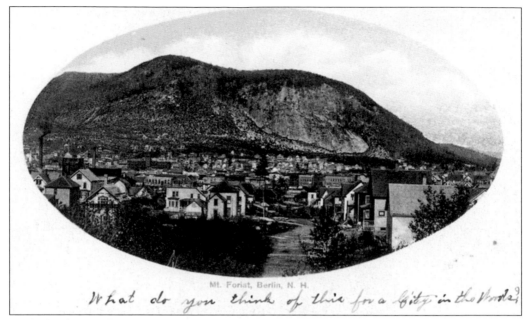

Mt. Forist, Berlin, N. H.

What do you think of this for a City in the Woods?

With the closing of the International Paper Company mill, the Depression, and World War II, the population of the East Side has steadily declined. Several large fires have changed the complexion of the housing, taking down large tenements that were replaced with smaller houses. Gone also are the fields high above the East Side on Enman Hill where there were several family farms.

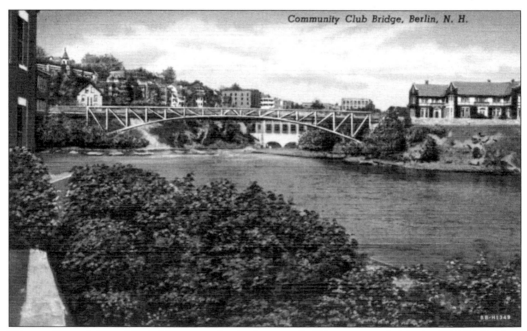

Community Club Bridge, Berlin, N. H.

The smallest of the public bridges over the Androscoggin River was probably the YMCA Bridge. Erected by Berlin Mills Company in 1913, it at first carried motor vehicles. By the late 1960s, the bridge, now known as the Community Club Bridge, was for pedestrian traffic only. It was torn down in 1981 and is still greatly missed, as it was a convenient shortcut to the East Side and the athletic fields.

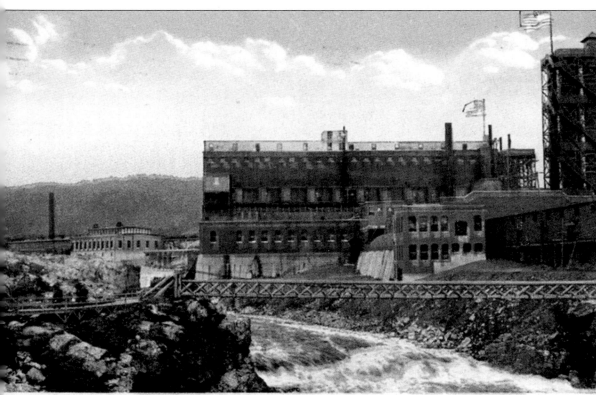

RGESS SULPHITE MILL AND SWINGING BRIDGE, BERLIN, N. H.

This pedestrian bridge across the Androscoggin River, built by Berlin Mills Company, was used by its workers on the west side to access the mills on the other side of the river. Only from here on the riverbank, the rock profile dubbed "Miss Riverside" by the workers, named for the Riverside mill, could be seen. The most recent bridge built in Berlin is named in honor of U.S. Rep. James C. Cleveland, who secured federal funding for the bridge. Built in 1981 in the southern end of the city, the Cleveland Bridge has had a major impact on the downtown as it provided direct access for the trucks to the pulp mills and the sawmills on the East Side, thereby diverting heavy traffic away from narrow Main Street. The loop formed by the bridge and its new street has become a popular walking area for its view of the mountains and the riverside garden that has been added in the last decade.

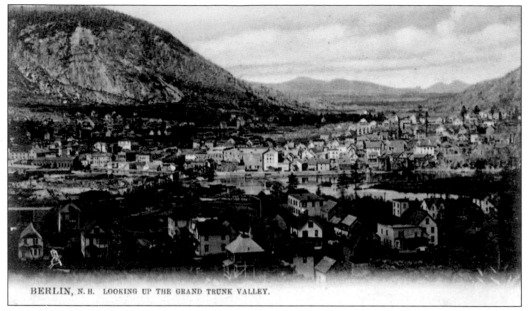

BERLIN, N. H. LOOKING UP THE GRAND TRUNK VALLEY.

So-called because this is the route the Grand Trunk Railway took when the line was extended from Gorham in 1852, Jericho Brook and the outflow of Head Pond become Dead River, which enters the city from the west between Mount Forist and Mount Jasper. This section of Berlin is known as Jericho. Mount Jasper is noted for a cave where rhyolite was mined for tools by Native Americans. (Courtesy Raymond Daigle.)

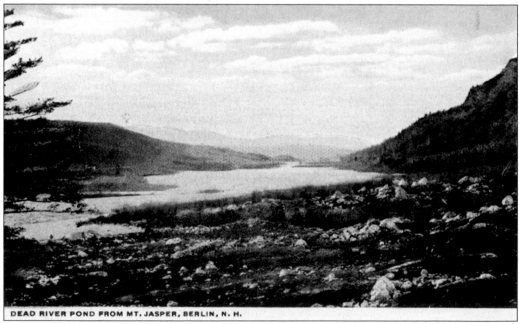

DEAD RIVER POND FROM MT. JASPER, BERLIN, N. H.

In 1874, Daniel Green drained the pond for his sawmill on the Dead River and planted cranberries. The crop was valued at $100,000 at the time. However, this venture never succeeded, as the growing season was too short for the berries to mature. Some of the cranberry plants survived and have become wild. Brown Company donated 300 acres of land on Jericho Brook on which the Jericho flood-control dam was built in the late 1960s.

Two

Main Street
and Downtown

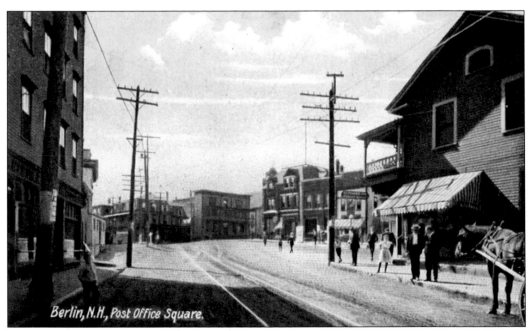

Berlin, N.H., Post Office Square.

Post Office Square was the original name of the square at the southerly entrance to Berlin's downtown. Before 1900, the post office moved with whoever was the postmaster. It was given a permanent home at 3 Post Office Square in 1901, but soon outgrew it. It was moved to the corner of Main and Mason Streets in 1918. Post Office Square then became known as Green Square.

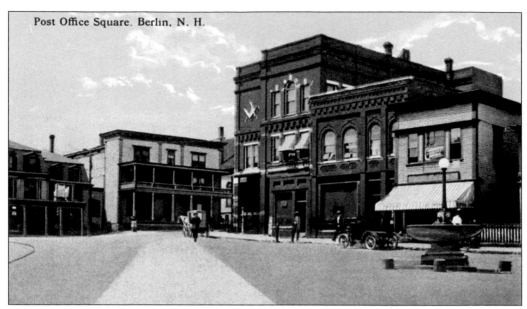

Post Office Square. Berlin, N. H.

Pictured here is Post Office Square around 1915. From left to right are the Berlin House at 3 Exchange Street, the Berlin National Bank, the Masonic hall, the Berlin Street Railway office, the post office, the office of Dr. Tappan C. Pulsifer and Dr. Thomas H. Gifford, and the Burgess Fountain on the square. Built in 1888 by Henry Marston, the Berlin House succumbed to fire in August 1961. Its owner, John Voudoukis, donated the site to the city in 1978, and it is now a park. (Courtesy Raymond Daigle.)

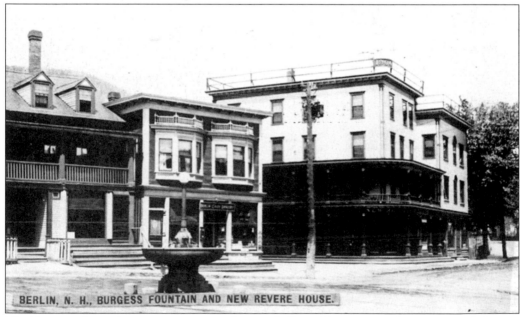

BERLIN, N. H., BURGESS FOUNTAIN AND NEW REVERE HOUSE.

The Burgess Fountain, a watering trough, was dedicated in 1905 to the memory of George Burgess by his wife's family and given to the City of Berlin because of his love of horses. A graduate of Harvard College, he came to Berlin to be superintendent of the Burgess Sulphite Fibre Company, where his brother Theodore P. Burgess was general manager. He died of appendicitis in 1902 at the age of 33.

In 1927, the Burgess Fountain was moved to pave the street. With the increasing number of automobiles, it was evident that the fountain was no longer needed as a watering trough for horses. Today it sits in a small park next to the Northway Bank. Flowers were planted in it for many years, but flowing water was restored in 2005 through the efforts of the Berlin Main Street Program.

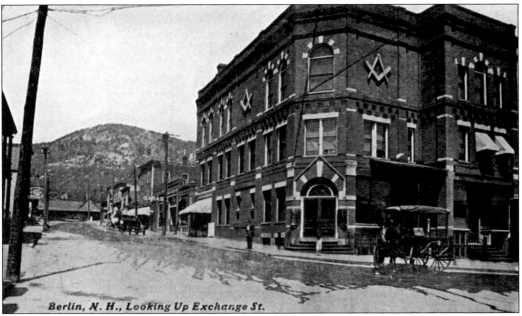

Berlin, N. H., Looking Up Exchange St.

The Grand Trunk Railway depot's proximity to the downtown can clearly be seen from Post Office Square. Several large hotels were located in the square for this reason. The depot seen in the distance is the third one to stand on this spot. The current depot building, which now houses offices, was built in 1917. All the buildings seen on the right side are now gone, replaced by a private parking lot. (Courtesy Raymond Daigle.)

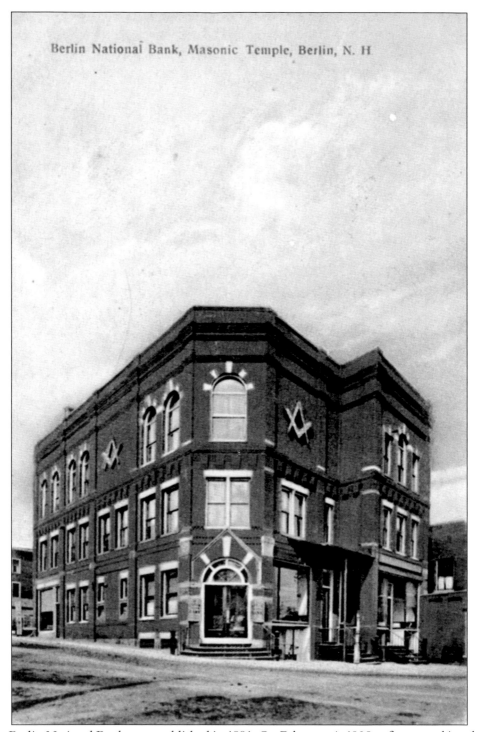

Berlin National Bank, Masonic Temple, Berlin, N. H

The Berlin National Bank was established in 1891. On February 4, 1908, a fire started in seltzer in the upholstering department of the E. A. Burbank and Company store adjacent to the Berlin National Bank. It soon spread to the bank. The bank opened the next day in the Bell Block on Pleasant Street.

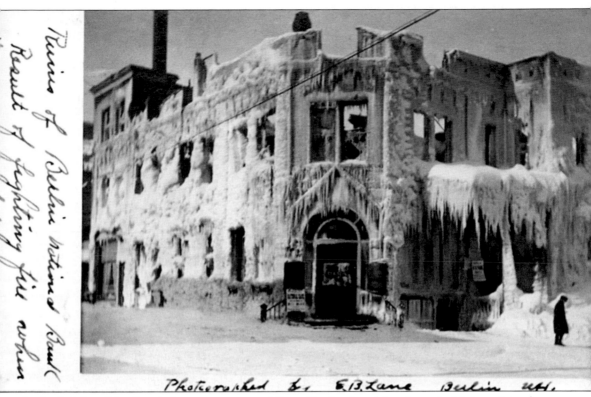

Ruins of Berlin National Bank Result of fighting fire when

Photographed by E. B. Lane Berlin N.H.

At the height of the fire, help was summoned from Portland and Lewiston in Maine. It took several hours for the steamers to arrive via rail. However, at nearly 30 degrees below zero, when they did arrive, they were frozen. For some time after the fire, the trolley could not reach the square from Glen Avenue, as the tracks there were flooded and frozen.

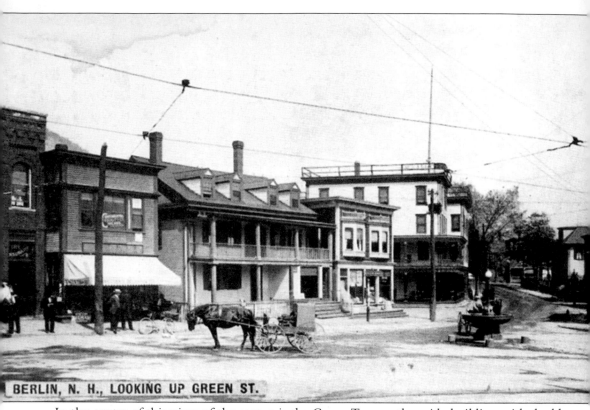

BERLIN, N. H., LOOKING UP GREEN ST.

In the center of this view of the square is the Green Tavern, the wide building with double porches and columns, which was later known as the Berlin Falls House. Beyond the tavern are the Cash Market and the Revere Hotel. The Green Tavern was Berlin's first frame building and first public house. Built in 1831 by early settler Thomas Green, it became a hotel and passed through several owners, including Merrill C. Forist. Daniel Green, son of Thomas, then became the owner and made it his home and operated a store there. In 1874, Daniel turned it over to his son Sullivan, who operated it as a boardinghouse. It was torn down in 1923 by H. Rosenfield, who built a three-story brick building in its place. This building had a store on the first floor, offices on the second, and apartments on the third. Dr. Irving Moffett, an osteopath, had his office there and lived upstairs with his wife, Mary, before moving to 119 High Street in 1949.

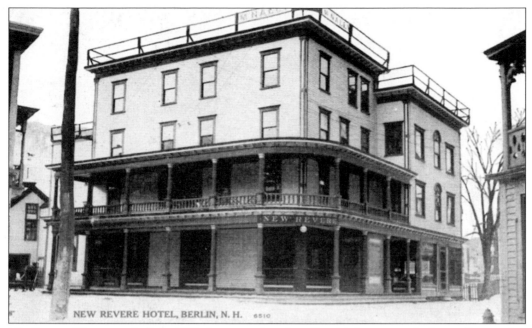

NEW REVERE HOTEL, BERLIN, N. H. 6510

The Revere House was built in 1888. It sat on a site where Daniel Green once had a small store that he opened in 1850. In 1904, it was remodeled by Foss T. McNally and renamed the New Revere House. This was a convenient place for business travelers arriving at the nearby Grand Trunk Railway station. The hotel was sold to William F. Costello in 1931. (Courtesy Raymond Daigle.)

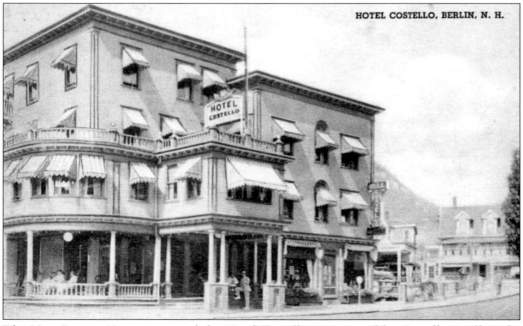

HOTEL COSTELLO, BERLIN, N. H.

The New Revere House, renamed the Hotel Costello, was moved by Costello to allow for traffic and a porte cochere entrance. Only the dining room was closed during the move. In 1948, J. Roland Champoux was the new owner. He maintained ownership until the hotel closed as the Costello Motor Inn in 1973. The Greyhound and Trailways bus lines ran from here. A Dunkin' Donuts now stands on this site.

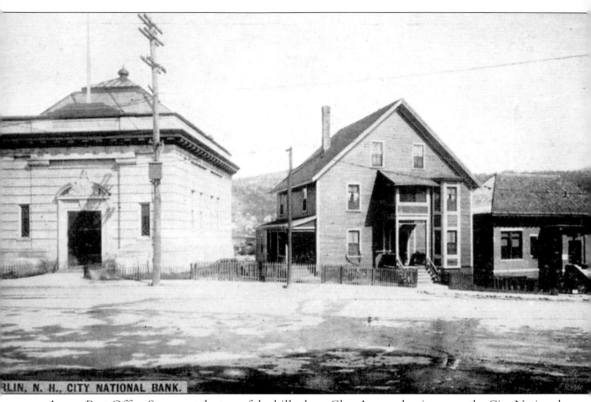

Across Post Office Square at the top of the hill where Glen Avenue begins were the City National Bank, a boardinghouse that was the clinic hospital between 1936 and 1953, and the International Paper Company time office at 5 Glen Avenue. This last building is the only one that remains of the mill. Morrison Dry Cleaners operated here from 1950 to 1978 and is now a hair salon. The clinic was physically connected to the former bank building by an enclosed walkway on the second floor, and both buildings were part of the clinic. Although several doctors worked here, the chief doctor associated with this establishment was Dr. Burton Munro, the husband of Lewis Brown. She is the daughter of Orton Bishop Brown of the Brown Company. After the clinic ceased operations, the connecting walkway was dismantled. Several offices and apartments were created in the wooden structure, which now stands vacant and derelict.

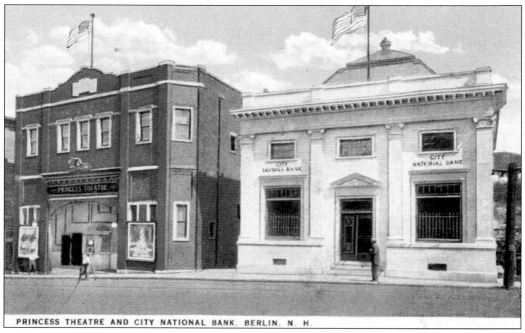

PRINCESS THEATRE AND CITY NATIONAL BANK, BERLIN, N. H.

The City National Bank building was constructed in 1904. The exterior was modified and expanded when the City Savings Bank joined City National Bank. In the 1960s, it housed radio station WMOU, which shared space with the United Brotherhood Credit Union, today called Woodlands Credit Union. Since 1969, it has been used solely as the Holiday Center, a senior center.

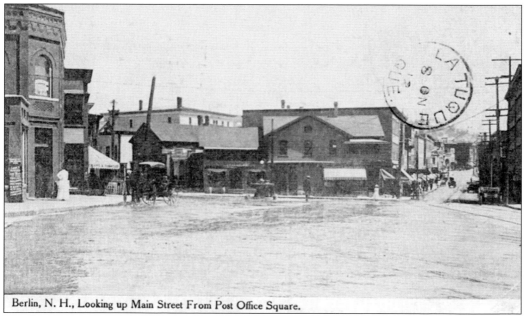

Berlin, N. H., Looking up Main Street From Post Office Square.

The wooden building on the corner of Main Street and Post Office Square was the Ira Mason house. He operated a store from here beginning in 1868. He lived and worked here until his death in 1883. The City National Bank began operations here in 1900, before erecting its own building across the square in 1904.

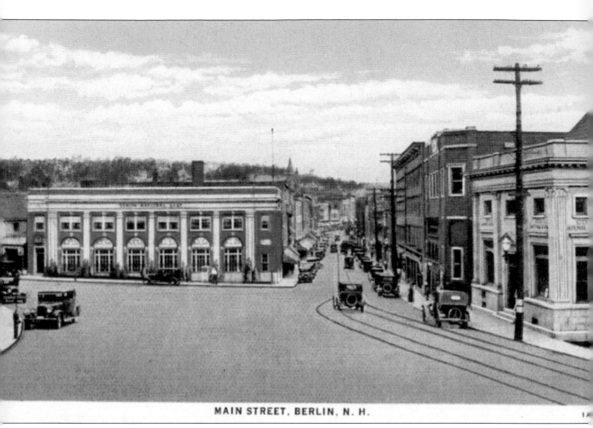

MAIN STREET, BERLIN, N. H.

The Ira Mason house was replaced with a new building erected in 1926 by the Berlin National Bank. This bank and City National Bank merged in 1934 to become the Berlin City National Bank. The first floor was occupied by the bank, and apartments comprised the second floor. City Savings Bank also was located here until around 1974. About 1980, the Berlin City National Bank expanded, taking over the entire city block except for the former Wilson Pharmacy building. Half of the block became parking for the bank. Its name has changed over the years to Berlin City Bank and finally, in 2006, to Northway Bank. A large collection of old photographs of Berlin is on display in its lobby and offices. Some parking for the employees is located directly across from the bank at 34 Main Street on the former site of a large block built in the 1880s and torn down in 1957, creating one of several holes in the former canyon of building walls that was Main and Pleasant Streets.

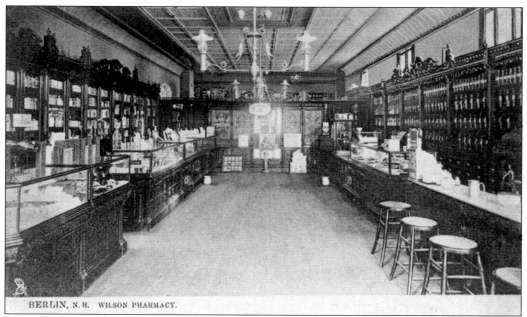

BERLIN, N. H. WILSON PHARMACY.

A pharmacy was established in 1880 at 35 Main Street by Henry Marble. It was sold to F. L. Wilson in 1885. The Wilson Pharmacy was a Rexall pharmacy complete with a soda fountain. The building was bought by Joe Fornia in the late 1960s. Kenneth Clark purchased it in the early 1970s and ran Office Products, an office–supply store, until his retirement in 2007. At that time, the Northway Bank bought the building and tore it down.

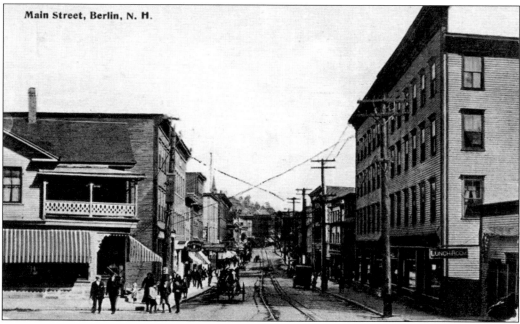

Main Street, Berlin, N. H.

In 1876, before the establishment of the first pulp mill, there were only five buildings on the easterly side of Main Street. The population in 1880 was 1,400. By 1920, the population had exploded to 16,104. Accordingly, the downtown had greatly expanded. Small shops and individual homes were no longer located in this area.

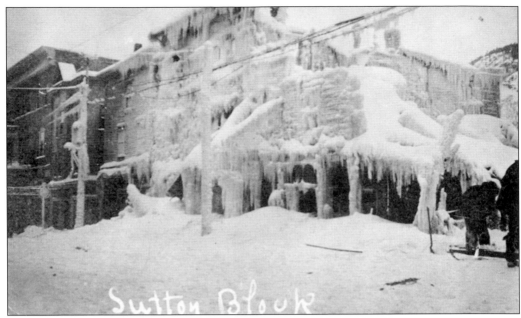

At the same time that the fire was raging on Post Office Square on February 4, 1908, fire broke out in the store of A. Brown and Company. It spread from the Sutton Block up to but not including the Gerrish Block on the westerly side of Main Street. The streams of water from the hydrants were weak, so people gave up and watched their properties succumb to the blaze.

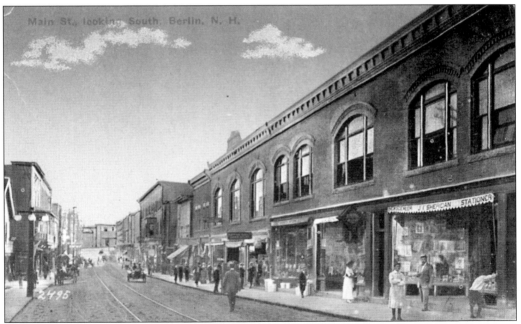

This is what the affected area looked like about 10 years later. New building codes mandated the use of bricks for the closely constructed blocks, in an effort to make them fireproof. The newly renamed Green Square can be seen in the distance. The post office was on Main Street by this time.

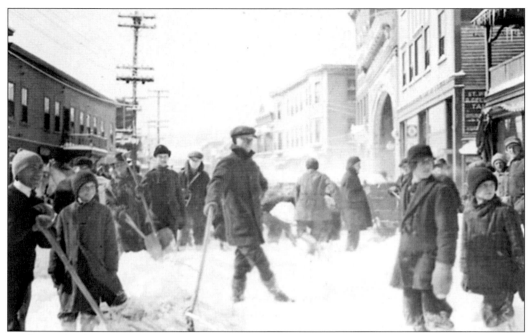

In the early days, snow removal was a major undertaking. Although the snow was rolled elsewhere in the city, it was removed manually downtown for the passage of the trolley and for the convenience of the storekeepers. Public works had a very large crew in this era, as all work was labor intensive.

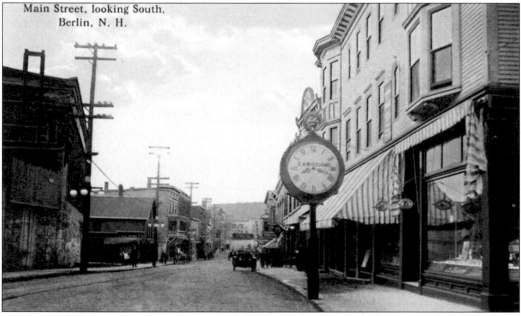

The large clock in front of the Gerrish Block was used as advertising for Whitcomb Jeweler. Solely owned by E. N. Whitcomb since 1909, the business operated out of the Gerrish Block for less than 20 years before moving to 146 Main Street. Whitcomb's daughter Leota married Spencer Rydin, and together they combined the jewelry store with the sale of children's clothing. Rydin's closed in 1968.

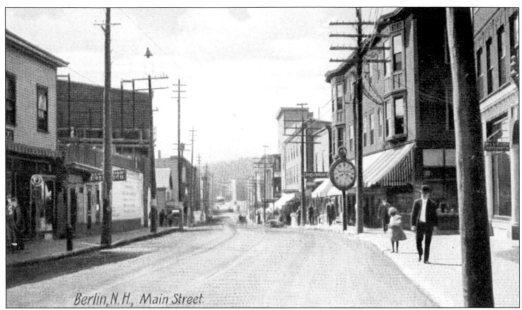

Berlin, N.H., Main Street.

The F. W. Woolworth Company was a downtown staple for many years. It moved from near Green Square to the Gerrish Block at 121 Main Street in 1930. Teenagers gathered in front on busy Friday nights. The police asked them to "move along." The lunch counter was an especially busy part of the establishment. This store closed in 1994. The front portion of the building was demolished and rebuilt in 1999.

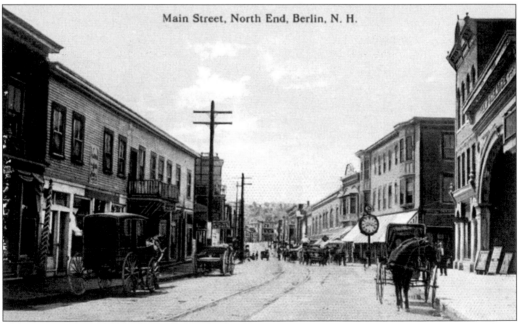

Main Street, North End, Berlin, N. H.

Though many businesses have come and gone in the downtown area over the years, some have had a surprising longevity. Gill's Flower Shop and Morin Shoe Store have been fixtures on Main Street for over a century as has Smith and Town Printers, although it is no longer owned by the Smith or Town families. Vaillancourt and Woodward Insurance Agency still has a member of the Woodward family involved in this concern.

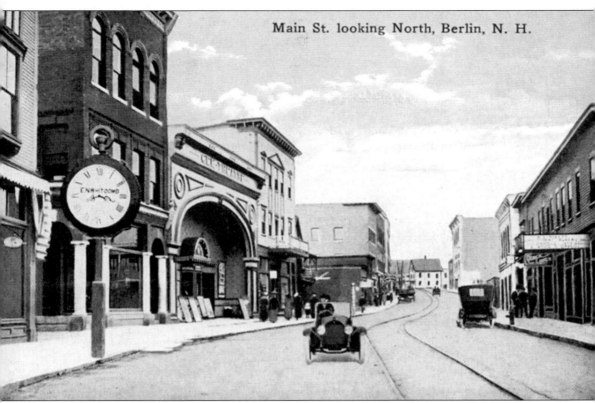

The building between the Gerrish Block and the Gem Theatre is the Berlin Savings Bank and Trust Company, which was established in 1890. Originally located in the Mason building on the square, it had its own building erected at 131 Main Street in 1902. In 1972, the bank moved to a new building at 173 Pleasant Street on a lot made available by the demolition of several buildings that was a result of the national movement called urban renewal. In 1983, it was known as the North Country Bank. It was bought out by First NH Bank and again by Citizens Bank in 1996 and remains so today. Its lobby is decorated with a magnificent wooden mural carved by noted local artist Robert Hughes, which was unveiled in 1978. Before his passing, Hughes was declared an official New Hampshire State Treasure.

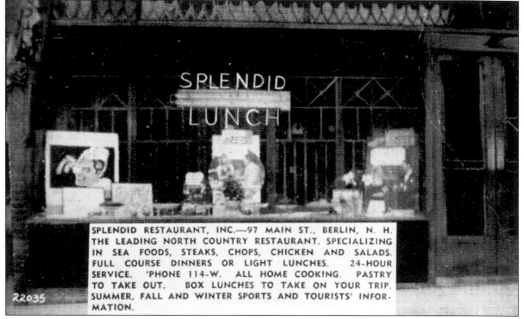

SPLENDID RESTAURANT, INC.—97 MAIN ST., BERLIN, N. H.
THE LEADING NORTH COUNTRY RESTAURANT. SPECIALIZING
IN SEA FOODS, STEAKS, CHOPS, CHICKEN AND SALADS.
FULL COURSE DINNERS OR LIGHT LUNCHES. 24-HOUR
SERVICE. 'PHONE 114-W. ALL HOME COOKING. PASTRY
TO TAKE OUT. BOX LUNCHES TO TAKE ON YOUR TRIP.
SUMMER, FALL AND WINTER SPORTS AND TOURISTS' INFOR-
MATION.

The Splendid Restaurant was just one of many small restaurants in Berlin's downtown district. Through the years, Priscilla's, Marie's, Emma's, Sheraton Restaurant, Dinner Bell, and the Pot Luck Restaurant could be found, as well as lunch counters at Woolworth's and Newberry. There was also Kay's Pastry Shop followed by Kelley's Pastry.

The restaurant tradition continues with Gold House Pizza, Wang's Garden, Toni's Pizza at the former Sheraton location, Tea Bird's, Tex Mex, and Supreme Pizza at the former Pot Luck location. However, there is no longer any lunch counter downtown. The only pastry shop is now located north of downtown in Norwegian Village.

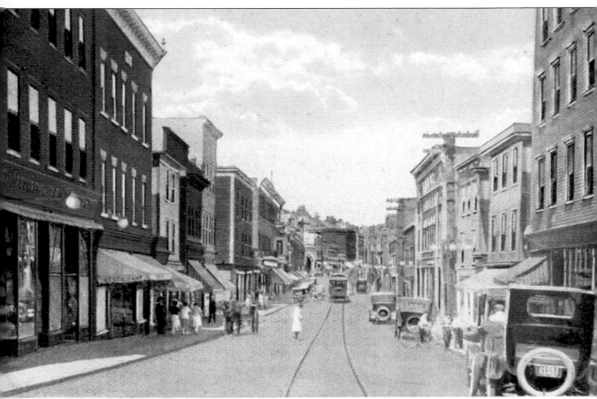

AIN STREET, LOOKING NORTH, BERLIN, N. H.

In 1976, fire struck a large block at 78 Main Street. It was torn down and never rebuilt, and Gill Park was created as a result. In 1991, another spectacular midwinter fire took place at the 131 Main Street location of the former Berlin Savings Bank and Trust Company. It was a Levi's jeans shop at the time of the fire. A single-story building was subsequently erected by Rite Aid. The Medicine Shoppe took over the building in 2007.

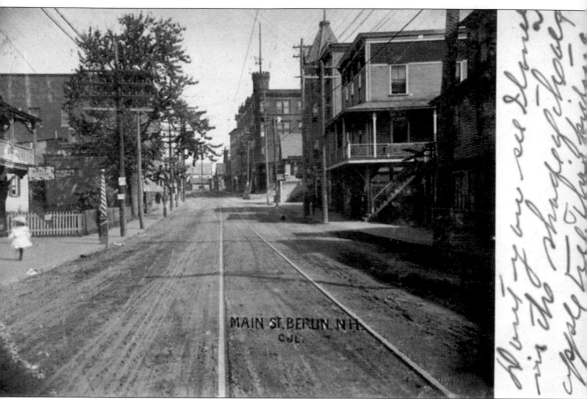

Looking north to the Clement Block with its tower around 1900, one can see the dirt streets of the era. Cement-concrete pavements were laid in Berlin in 1909. They were the first such roads in New Hampshire. This was more advantageous for the motored vehicles that were beginning to come into favor. It was also a big improvement over the mud that was tracked into the stores after a rainstorm.

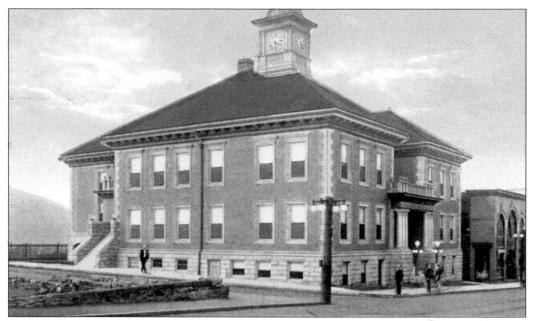

City hall was originally located in the municipal building on Mechanic Street in downtown Berlin. The dedication of a larger, more modern building on the southeast corner of Main and Mason Streets was held on November 24, 1914. The building has hardly changed since then, with the notable exception of the police department getting its own building. Note the vacant lot across the street where the post office was later built.

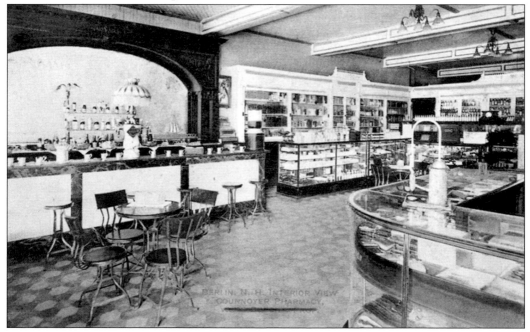

The Cournoyer Pharmacy, located at 175 Main Street across from city hall, was in operation for about a dozen years. The business was sold and renamed the Moffett Pharmacy in 1924. By 1934, it was LaRochelle's Pharmacy. In the 1960s, Gowdy Pharmacy occupied this space. In 2008, it is the Tex Mex café.

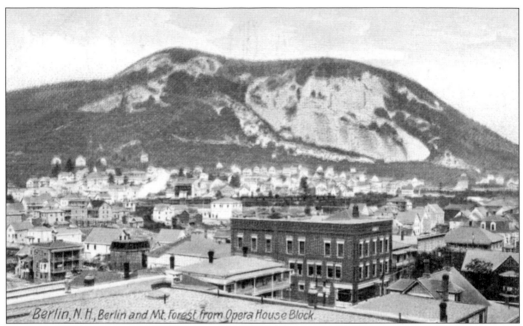

Berlin, N.H., Berlin and Mt. Forest from Opera House Block.

When the four-story Clement Opera House was here in 1903 (above), there were only smaller wooden buildings across the street. The large brick block seen in the center is one block over on the corner of Mason and Pleasant Streets. Mason Street travels east–west, while Pleasant Street parallels Main Street north–south. Later, when the Albert Theatre replaced the Clement Block after it was destroyed by fire (below), larger brick buildings became the norm in the downtown area. Both of these buildings were built by Theodore Morin and are across Mason Street from each other. Note how the name of Mount Forist is misspelled in both postcards, as is often the case. (Above, courtesy Raymond Daigle.)

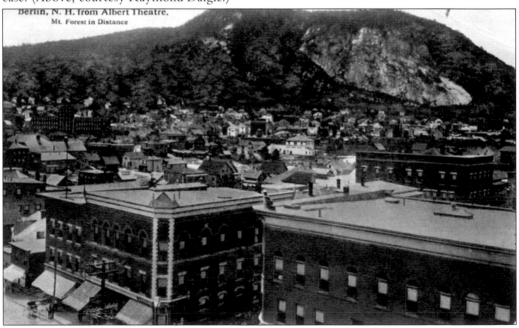

Berlin, N. H. from Albert Theatre,
Mt. Forest in Distance

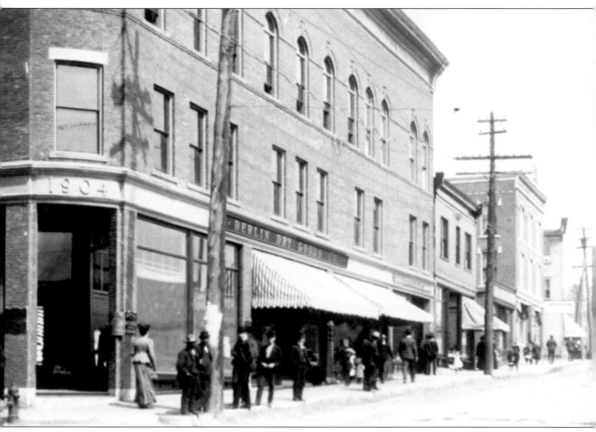

The Morin Block, situated on the northwest corner of Main and Mason Streets, succumbed to fire in November 1939. One of the occupants was J. C. Penney, which later occupied a two-story building that replaced the Morin Block. It has been there ever since. Unfortunately Berlin Dry Goods relocated to the Morin Block from its previous location in the Clement Block after it too had been destroyed by fire. (Courtesy Raymond Daigle.)

OST OFFICE, BERLIN, N. H.

A new post office was built in 1918 on an empty lot on the northeast corner of Main and Mason Streets. This lot was the result of a smaller Albert Theatre being built on the site of the Clement Block. The current post office was erected on the corner of Pleasant and Mount Forist Streets in 1965. The 1918 building was demolished almost immediately after being vacated. A service station replaced it. Today it is a realty office.

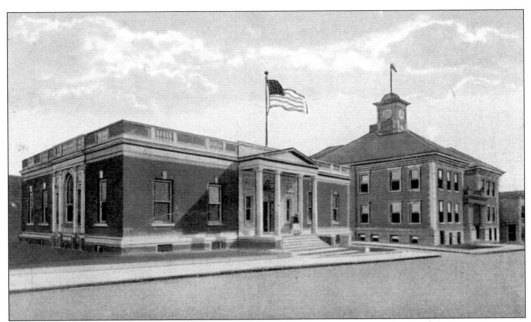

The years 1903 to 1920 were a boom time for the city. This era was marked with a large increase in building downtown as well as throughout the city. During this time, the Central Fire Station, the public library, city hall, the post office, churches, schools, the hospital, theaters, the Cote Block, and the Hodgdon building were built. Good use was made of the Italian brick layers who finished building the Cascade mill in 1903.

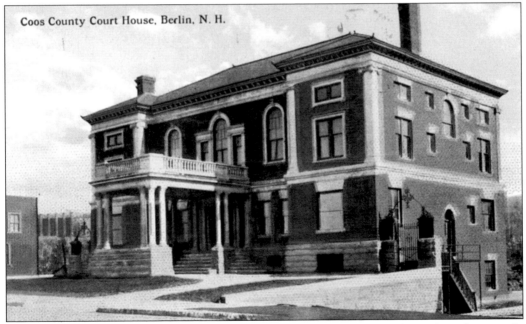

Coos County Court House, Berlin, N. H.

The Coös County Courthouse, today the Berlin District Courthouse, is located on the easterly side of Main Street in the second lot above the Albert Theatre. Completed in 1906, it originally had a porte cochere and a front lawn. A canon was placed on this lawn after World War I, and it was removed for scrap during World War II. The front lawn is now paved for parking.

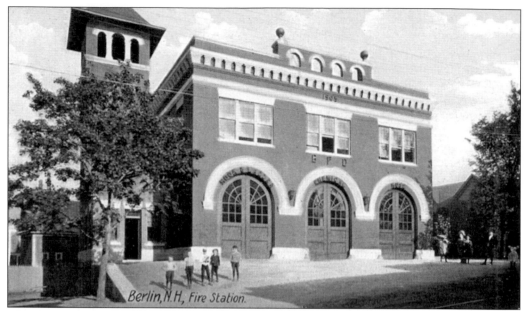

Berlin, N.H., Fire Station.

The Central Fire Station on Main Street was built in 1905. It housed horses and horse-drawn equipment until about 1916 when the department began to modernize with motor vehicles. This fire station is the only one of the four in the city still in use. The others were either torn down or refitted for other purposes. Modern fire engines are kept in this century-old building without need for many changes.

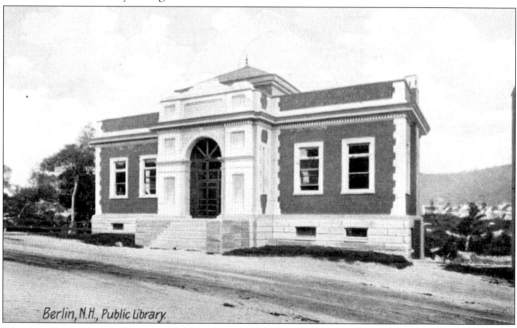

Berlin, N.H., Public Library.

The Berlin Public Library on Main Street opposite the Central Fire Station is one of many libraries funded by the Andrew Carnegie Corporation. It was constructed on land donated by the Burgess and the Berlin Mills Companies and dedicated on October 4, 1904. Prior to this, the Berlin Mills Company maintained a circulating library. Its contents were given to the city when the public library was built.

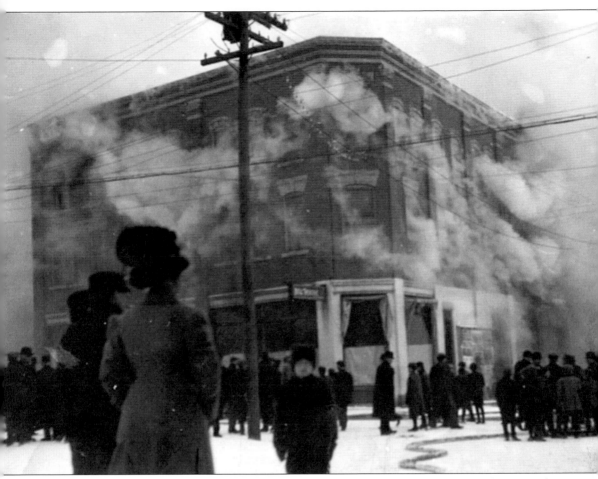

The Bell Block, located on the corner of Pleasant and Mechanic Streets, was built by J. Fred Bell. Bell owned livery stables, an icehouse and delivery business, and many other enterprises. At this time, the *Berlin Reporter* office was housed here. The building survived fires, such as the one pictured and another in December 1932, only to be taken down as part urban renewal in the late 1960s.

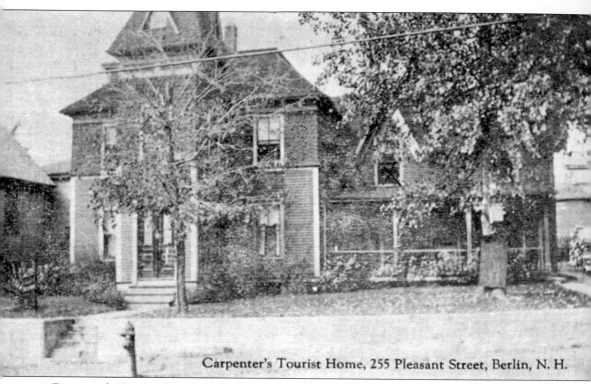

Carpenter's Tourist Home, 255 Pleasant Street, Berlin, N. H.

Carpenter's Tourist Home at 255 Pleasant Street was owned by Mr. and Mrs. M. B. Carpenter. The house was later bought by Fred Prince, a grocer and local philanthropist who notably worked with the Red Cross and the Salvation Army. The proximity to his grocery stores allowed him to walk to work, never missing a day. (Courtesy Raymond Daigle.)

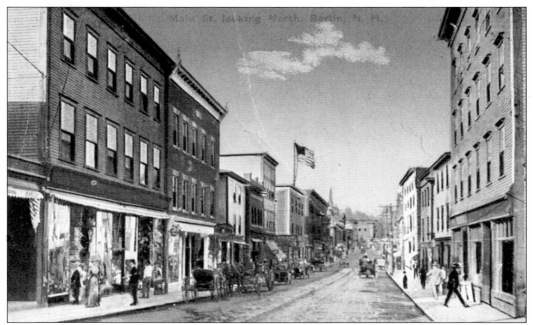

The downtown district in the first half of the 20th century was a vibrant, busy area. Policemen had to walk their beat in the street on Friday nights as the sidewalks were so crowded with pedestrians. Today traffic on Main and Pleasant Streets travels one way, and there is no longer an electric trolley. Before 1940, each street had two-way traffic, the streetcar, and parking on both sides of the street, making for a congested scene. There were also 28 bars in Berlin in the days before television. The men seen below are standing in the middle of the Main Street and Mason Street intersection, something that cannot be done today due to the increase in vehicular traffic since after World War II. (Below, courtesy Raymond Daigle.)

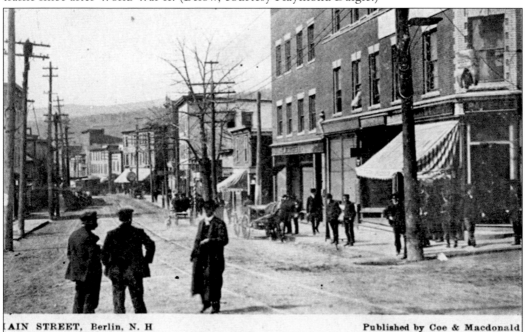

IAIN STREET, Berlin, N. H Published by Coe & Macdonald

Through the years, there have been several bottling companies in Berlin, including People's Bottling Company, owned by Joseph Blais in 1915; Eagle Bottling Company, owned by N. Morin and Son in 1915; City Bottling Company in 1920; Coca Cola Bottling Company in 1930, which moved later to Gorham; and the Royal Crown and Orange Crush Bottling Company on York Street through the 1950s and 1960s.

Three

SOCIAL ACTIVITIES

Clement Block, also known as the Clement Opera House, was built on the northeast corner of Main and Mason Streets in 1895 by Fred M. Clement, who was mayor of Berlin in 1901 and 1902. Stores occupied the first floor with the opera house–theater and suites on the upper floors. This magnificent building burned down on January 5, 1905, taking the Larochelle building and the Brooks residence across Mason Street too. All the apartments in the Clement Block and the Gagnon Block just north of it were occupied. Another building east of the block toward the Mason Street bridge was also engulfed in flames. The Clement Block was not rebuilt. Note the picket fence across Main Street. There were still private residences on Main Street at this time.

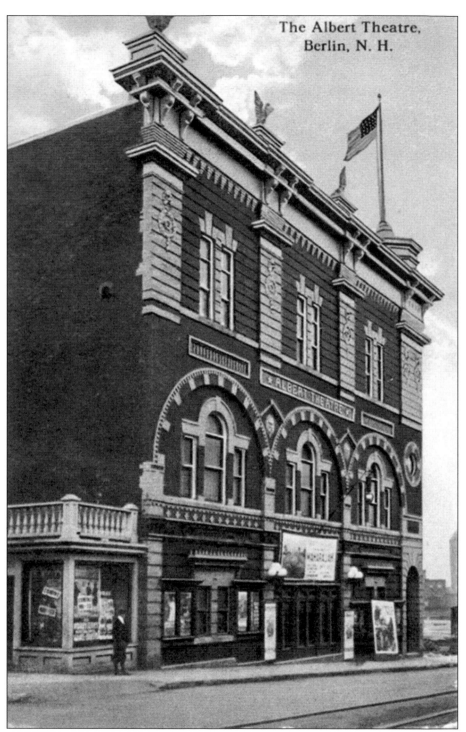

The Albert Theatre,
Berlin, N. H.

Albert Theatre was built on the upper lot of the site of the Clement Block in 1905 by Albert Croteau. Graduation exercises were held here as the school auditorium and the new city hall with its own auditorium were not yet built. On November 23, 1907, the four-story brick building burned. The Albert Theatre was rebuilt with three stories and reopened in January 1911.

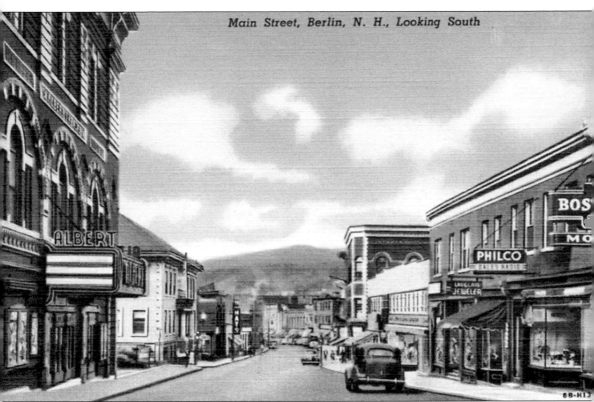

The theater organ was moved to the auditorium of the senior high school in 1937 where it still resides. The theater closed in the mid-1950s. The W. T. Grant department store moved into the building from lower Main Street in 1957. It used the basement and first floor, gutting the other floors for use as storage. It closed in 1974. The building is still vacant, but the facade has been renovated by its new owner.

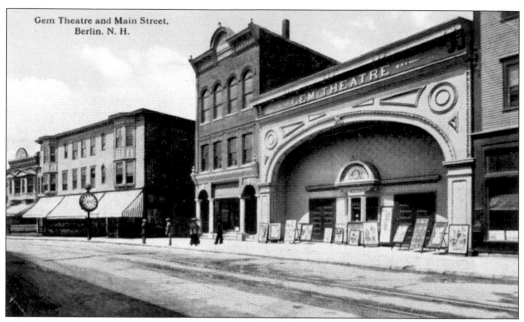

The Gem Theatre, located at 135–137 Main Street and erected in 1908, was the first theater built specifically to show movies. The first movie in Berlin was shown at the music hall in 1906. In 1914, the Gem Theatre became a dance hall, and then it became a bowling alley in 1924. By 1930, this lot was occupied by the J. J. Newberry department store.

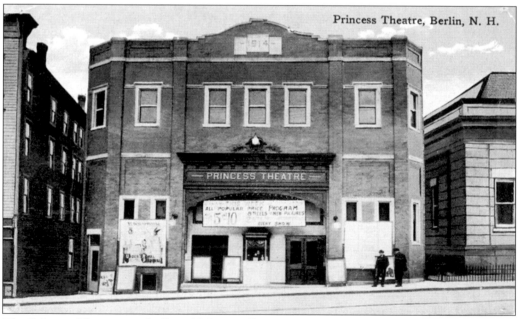

The Princess Theatre was built at 25 Post Office Square in 1914. It closed in the 1940s. It was reopened by John Voudoukis in 1961. Owned by William Goudreau in the 1970s, it became the Royal Twin Cinema after being divided in half to allow the showing of two movies at once. It has changed hands several times since the 1990s. Longtime residents still refer to it as the Princess Theatre.

Henry Hart Furbish, owner of the Forest Fibre Company, bought property on the corner of High and Main Streets from a Mr. Ellis in 1882. He then tore down the small house and built this handsome residence. Abraham M. Stahl bought this house in 1898. The Elks club owned the property and used it as their lodge from 1924 until 1930. In 1934, it became the Moose lodge.

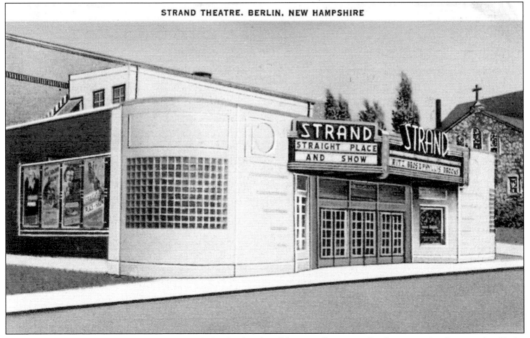

By 1937, the Strand Theatre replaced the lodge building. This was the last movie theater built in Berlin. The Strand, the Princess, and the Albert theaters were managed by Edward O. Gilbert. The Strand closed in 1962 and was converted into the Berlin Bowling Center around 1967, which it still is today.

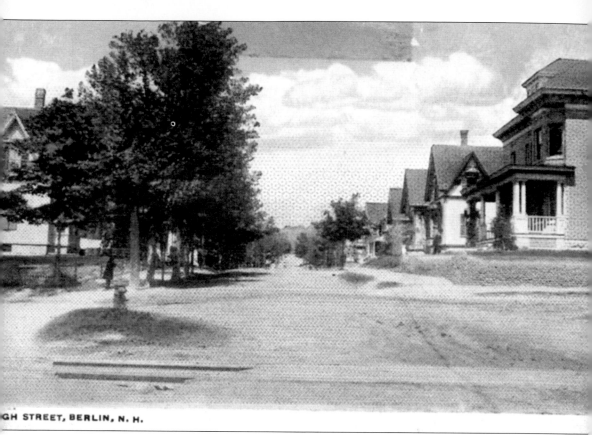

Henry Hart Furbish, along with his partner in his mill, Jerome Bacon, owned large tracts of real estate in the surrounding area. Lower Church and School Streets were known as "Fibreville" after the single-family homes built for workers at his Forest Fibre Company. His land holdings extended up High Street to Hillside Avenue. (Courtesy Raymond Daigle.)

The property that Furbish and Bacon owned included the land where the Moffett House Museum and Genealogy Center stands today. Originally built in the 1890s on the corner of High and Emery Streets, Dr. Irving and Mary Moffett bought the house in 1949 from the estate of Anna Gross, who owned the Berlin Street Railway. It was donated to the Berlin and Coös County Historical Society by Mary Moffett in 1996.

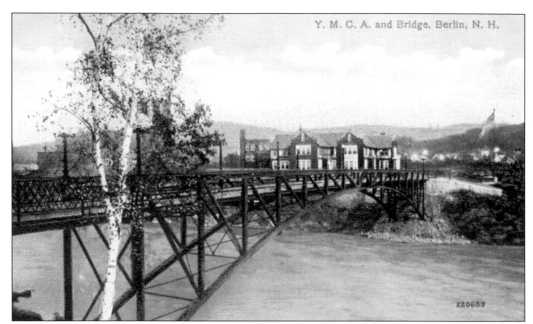

William Wentworth Brown did not give the land and the money to build the YMCA outright as this would have seemed like a monument to him. Instead, he wanted the citizens of Berlin to have ownership of the building by contributing toward it. During the week of March 17, 1913, the city had six days to raise the necessary funds, but ended the campaign after four days because their goal was reached.

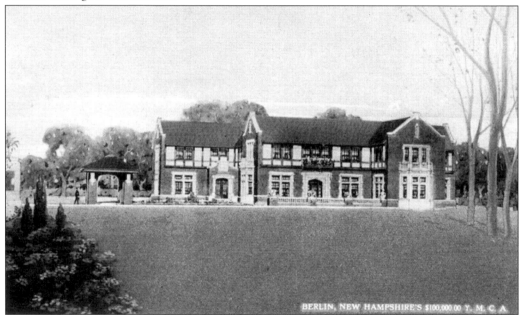

BERLIN, NEW HAMPSHIRE'S $100,000.00 Y. M. C. A.

The City of Berlin, the International Paper Company, and the Burgess Company also contributed financially to the YMCA. Brown's share was $40,000, while the others totaled $86,000. Brown's son Orton Bishop Brown took his father's place championing this addition to the city after his father's death in 1911. The building contained a swimming pool, gymnasium, bowling alleys, offices, and a large lobby. Outdoors, there were ball fields and tennis courts. (Courtesy Raymond Daigle.)

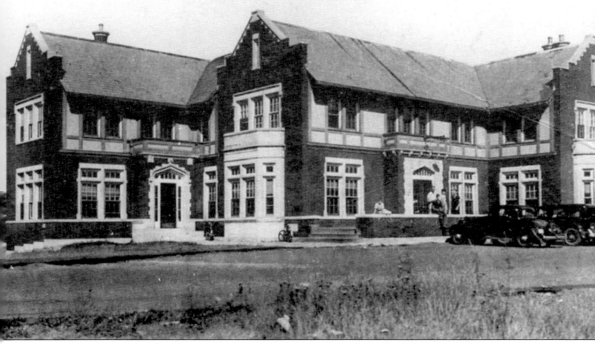

In 1929, 900 men and boys were members. In 1936, the board of directors disassociated themselves from the YMCA and changed the name to the Community Club. Now women could join. In 1951, it was reconditioned and repaired. The club was sold in 1973, becoming Riverside Tavern. It was torn down in 1980. The baseball fields remain, but the tennis courts are now across the street.

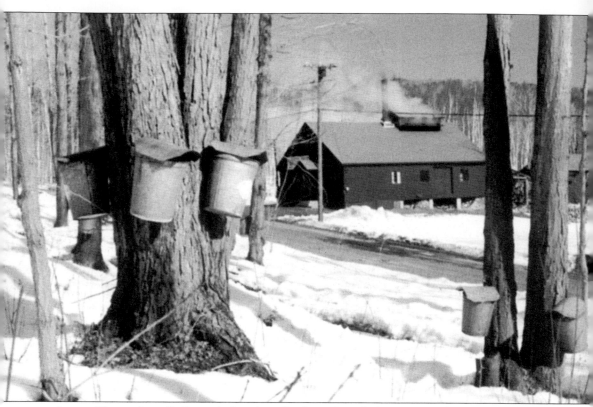

Lazare Bisson, from St. Leon de Standon, Quebec, Canada, began Bisson's Sugar House in 1927. A new sugarhouse was built several hundred yards down the road from the original one on Cates Hill in 1951. It has been in continuous operation by the family. Today it is owned by Muriel and Lucien Blais. Muriel is the niece of Armand Bisson, the previous owner.

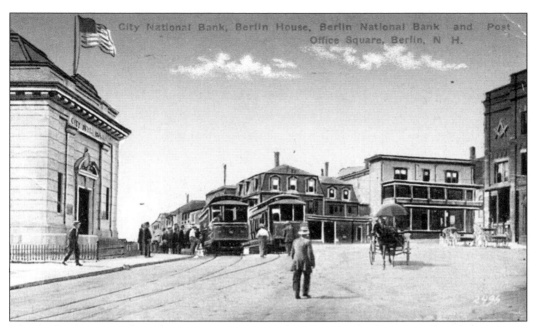

The Berlin Street Railway began operating on July 4, 1902. The line started on upper Main Street at the Berlin Mills bridge, proceeded down the center of Main Street in the business district, then continued south along the easterly side of Route 16 to the Berlin-Gorham town line. From there, it descended into Cascade Flats and then went on to Gorham. The line ended where Main Street meets Exchange Street.

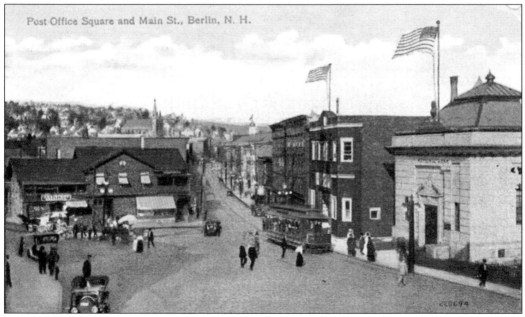

Post Office Square and Main St., Berlin, N. H.

There was no turn-around in Gorham, so the railcars simply reversed home. In all, the line was 7.5 miles long and took one and a half hours from its inception. Fares were 5¢ from Berlin Mills to Cascade and another 5¢ from Cascade to Gorham. The trolley was powered with electricity from Cascade Light and Power, which operated the hydroelectric station at the Cascade mills.

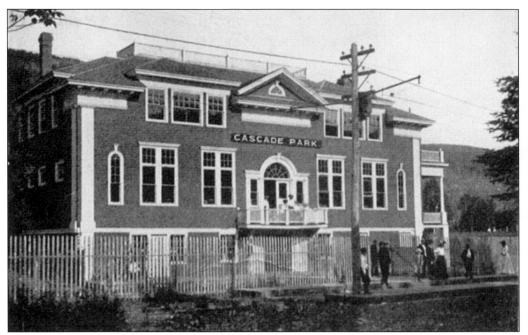

In late 1902, the railway bought the Gerrish farm in Cascade to create Cascade Park. A casino was built with a ballroom on the first floor and a banquet hall on the second. Later a baseball field, tennis courts, and a croquet ground were added. In 1931, the Cascade Casino was torn down by the Brown Company, who purchased it along with the park several years before.

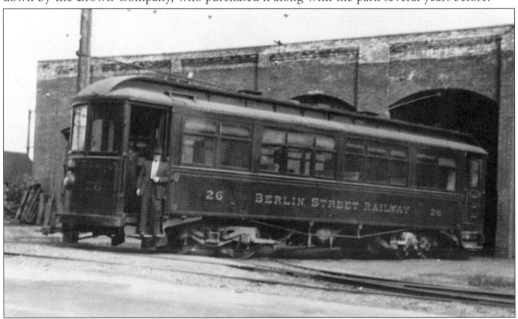

By 1938, the rolling stock was aging and the railroad ties in the now-paved streets were deteriorating. The decision was made in August 1938 to petition public service to substitute motor coaches. The petition was granted and buses were ordered. These buses ran until 1954, also yielding to the independence offered by automobiles. The carbarn still stands on Glen Avenue and is today an automobile parts store.

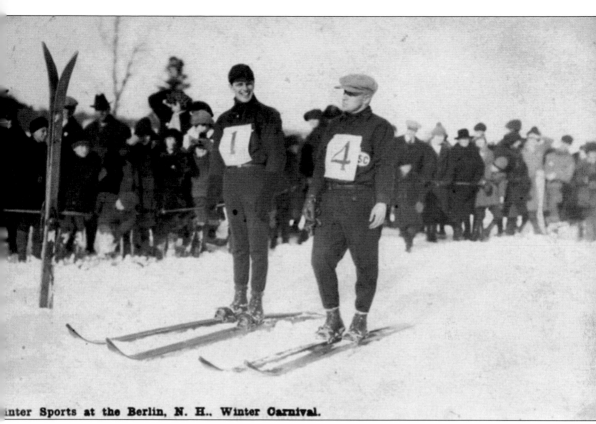

inter Sports at the Berlin, N. H.. Winter Carnival.

A ski club was informally organized in 1872 by Berlin's Scandinavian population, making it the oldest ski club in the Unites States still in existence. The first ski jump was built on what is now Heritage Lane next to the Brown Company House in the Berlin Mills section of the city south of Norwegian Village and across from the Berlin Mills sawmill.

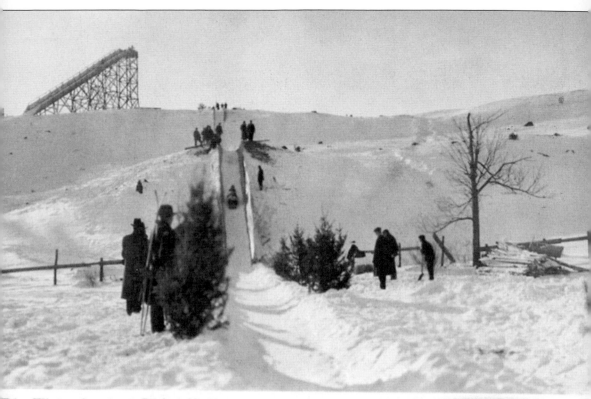

B6—Winter Sports at Berlin, N. H.

The ski jump was moved first to Austin Field on Samuel Paine's farm just north of the Norwegian Village near Twelfth Street, then it was moved again to the lower pasture of this farm. In 1905, the ski club officially became the Skiklubben Fritjof Nansen, named for the Norwegian who crossed Greenland on skis. Nansen visited his namesake club in 1929.

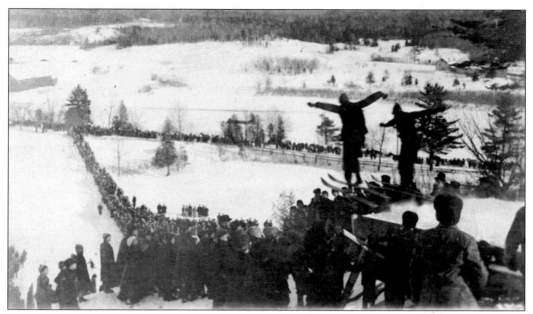

The position of the ski jump was changed in 1927 to where it remained until 1938. It became a permanent structure and was the largest in the east until the jump at Lake Placid was built. The Nansen Ski Club was the only club to send three representatives to the 1932 Winter Olympics at Lake Placid, including Alf Halvorsen, who coached skiers in the combined events; Erling Anderson, a ski jumper; and Robert Reid, a cross-country skier. Two local skiers are shown jumping simultaneously.

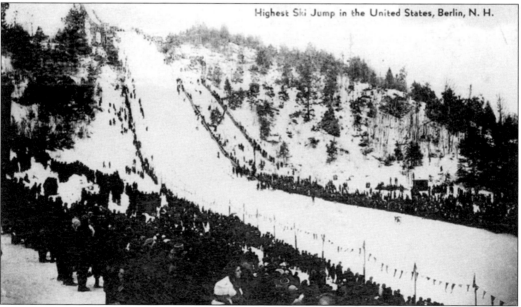

In 1938, a new steel tower was built just over the town line in Milan. It was constructed with federal aid by men working through the National Youth Administration (NYA). The tower stands 172 feet and was the tallest ski-jump tower in the United States. Olympic trials and national championships were held regularly through 1985. The tower still stands and is visible from a distance, especially from the north looking south.

The large Scandinavian population provided the impetus for the city to have winter carnivals beginning in 1922. Events as varied as skijoring and snowshoe races, as well as woodsmen's sports, such as log chopping, took place over three days. Large crowds walked up to the northern end of the city to watch the main event of ski jumping.

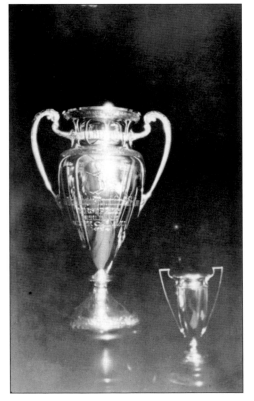

Secretary of War John Wingate Weeks, who was born, raised, and at the time a summer resident of Lancaster, the county seat of Coös County, had a silver cup made to be presented to the winner of the 25-mile cross-country ski race from the halfway house of Mount Washington to the site of the Berlin Winter Carnival. The cup was won by Robert Reid.

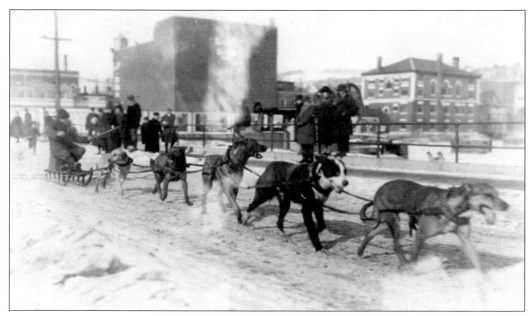

The first dog sled derby held in New England took place in 1922 and lasted three days. The course took the sleds from Berlin north to Colebrook then south to Lancaster and back to Berlin. The Brown Corporation sponsored a team that competed at the Eastern International Dogsled Derby in Quebec. It usually came in first or second. (Courtesy Raymond Daigle.)

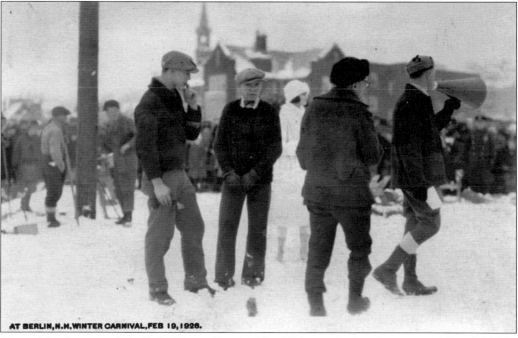

AT BERLIN, N.H. WINTER CARNIVAL, FEB 19, 1926.

One of the features of Berlin's Winter Carnival in 1926 was the logging competition. Held in YMCA Field, now Community Field, this was a very popular aspect to the carnival. Logging competitions in general began in the north woods of New England then traveled west with the loggers. The man seen on the right with the megaphone is announcing the next competition, undoubtedly having to do with the pole standing behind them.

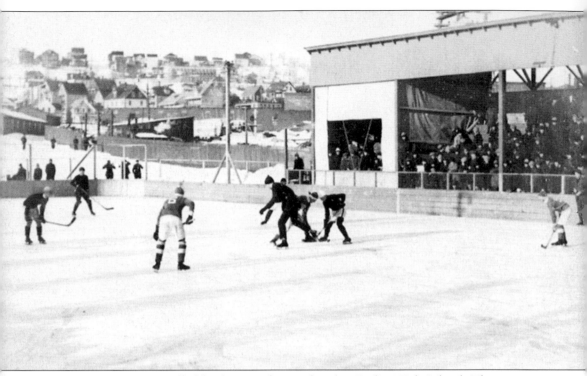

In 1903, a new sport called hockey was being played at Berlin High School. The games were held at the YMCA Field, later known as Community Field on the east side of the Androscoggin River, which is pictured here. The winter of 1919–1920 saw the formation of the Berlin Rink Association Hockey League that consisted of four teams: Town, Cascade, Burgess, and Berlin Mills. Brown Company owned mills in Canada that also had teams. In January 1920, a team of Berlin all-stars took on teams from the Sherbrooke and the LaTuque mills, winning both games. In February, Berlin traveled to these towns to take them on and again won both games. Berlin's self-given title of "Hockeytown USA" was beginning to take shape. Ice hockey came indoors when the Notre Dame Arena was built in 1946 by Rev. Omer F. Bousquet at the site of the Coulombe rink on Hillside Avenue.

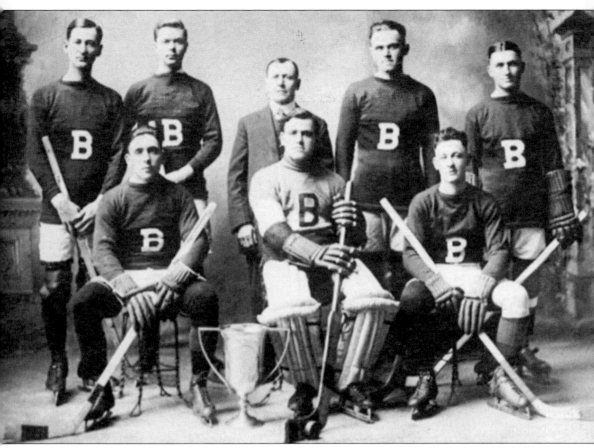

Although the greatest accomplishment was probably the adult-league team Berlin Maroons winning the national championship in 1954 and 1967, locally, the intense rivalry in hockey was keenest between the public Berlin High School and the Catholic Notre Dame High School. In the short history of Notre Dame High School from 1942 to 1972, its hockey team won 19 state championships, 16 of them between 1947 and 1962. Their streak was broken by Berlin High School. The New England Schoolboy Championship was won in 1957 by Notre Dame High School and in 1967 by Berlin High School, which cemented the "Hockeytown USA" moniker. The year Notre Dame High School closed its doors, its hockey team went out as state champions. Disaster struck during the deep snows of the winter of 1968–1969. In February 1969, the roof of the arena collapsed during warm-ups for the Berlin High School versus Notre Dame High School junior varsity game. The 15-year-old Notre Dame High School goalie was killed. The arena was rebuilt and had more than $250,000 in renovation work completed in 2007. It continues today as one of the symbols of the origins of hockey in New Hampshire.

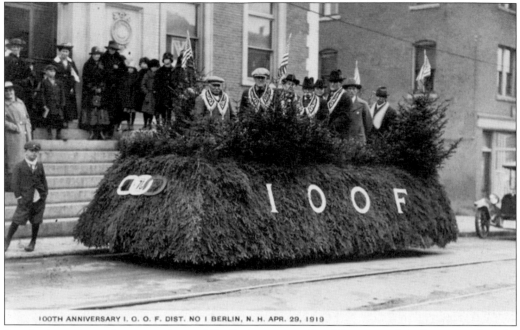

Parades have always been popular, and Berlin is no exception. Here a parade is the centerpiece for the centennial celebration of the International Order of Odd Fellows in 1919. No effort was spared in the decoration of elaborate floats. Especially large parades were held for the city's centennial and sesquicentennial celebrations. Some parades were even held in winter for the carnivals.

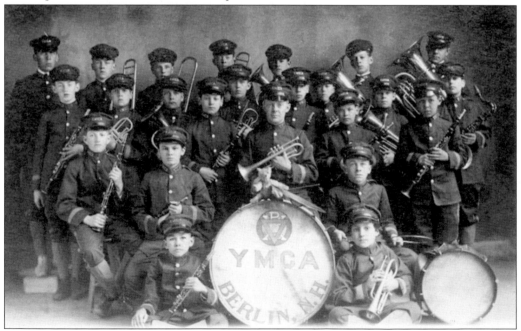

What would a parade be without a band? Berlin certainly has had its share of bands; even Brown Company sponsored several bands. The first one it sponsored was the Normana band in 1882, followed by the Burgess Band, the Brown Company Band, and Oleson's Band. The YMCA also had a band, as did several schools. Berlin High School still has a concert band.

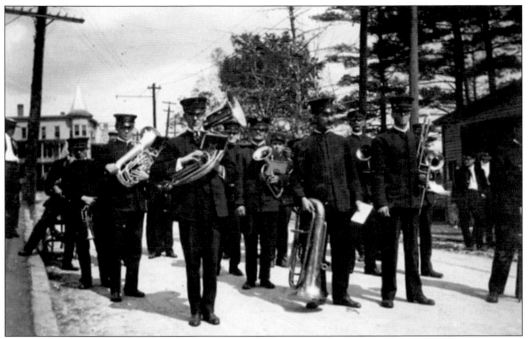

The Everett Brass Band is getting ready to march in a parade down Main Street in 1911. They are standing at the intersection with Pleasant Street, as noted by the St. Louis Hospital in the background. The man in the white shirt near the telephone pole is the leader of Grahams Orchestra.

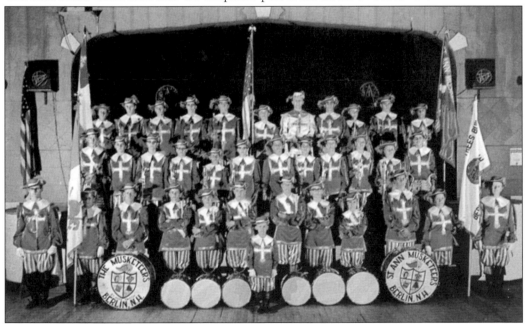

Perhaps the band with the most elaborate costumes was the Musketeers. It is said that the Three Musketeers candy bars in the 1950s contained information for sending away to get a pattern for the costume. A pattern was procured, and mothers made the uniforms. This band won several competitions for best costume. The band only existed from the late 1950s into the early 1960s and was associated with St. Anne Roman Catholic Church.

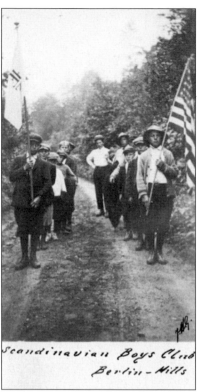

Also popular in parades were the fraternal and social clubs of which Berlin once had many. There were the Moose, the Elks, the Knights of Pythias, the Maccabees, the Scandinavian Boys Club, and the Catholic Foresters. Remaining still are the Association Canado-Americain, the Knights of Columbus, the Daughters of Isabella, the Fraternal Order of Eagles, the Kiwanis, and the Rotary Club, among others.

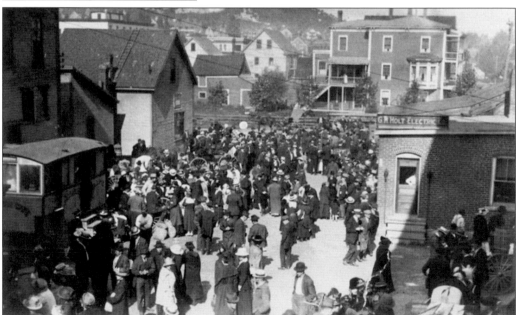

This public market was held on Bickford Lane, located between the Gerrish Block and Berlin Savings Bank and Trust. It was closed to vehicular traffic for the occasion. Cars crossed from the east on Main Street to the west on Pleasant Street until the 1980s when bricks were laid to make a pedestrian walkway. Crab apple trees line the walkway. The site of Holt Electric is now a parking lot for the Medicine Shoppe.

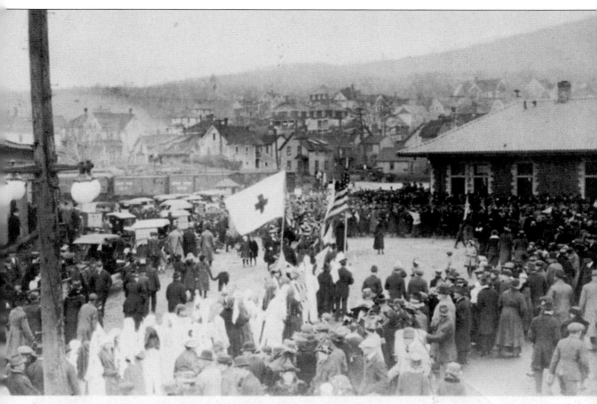

RETURN OF CO. L- 26TH. DIV. BERLIN, N. H. APR. 29, 1919

Here Company L of the 26th Division is being warmly greeted upon its return to Berlin from World War I on April 29, 1919. The throng is massed at the Grand Trunk Railway station on Mount Forist Street in Depot Square. The Avenues section of Berlin is just beyond the railroad tracks. The Grand Trunk line was later sold to Canadian National and then St. Laurent and Atlantic. The East Side of Berlin also had a train station. The Concord and Montreal Railroad completed an extension from Jefferson in 1891, making Berlin the terminus. In the fall of 1892, two or three boxcars of bricks were brought in to build the Burgess Sulphite mill. Passenger service began the following year to the station that was built across the street from Community Field. In 1896, this line was leased to the Boston and Maine Railroad. It was discontinued in the early 1960s. The tracks were torn up as part of the Rails to Trails project in the early 2000s. This station is currently the Eastern Depot restaurant. (Courtesy Raymond Daigle.)

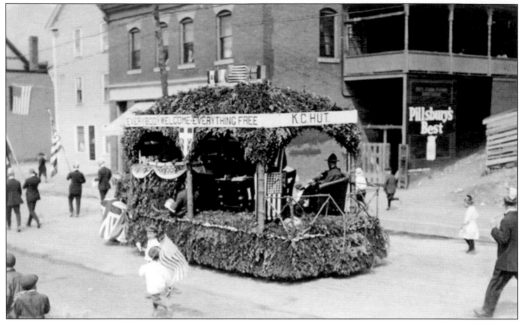

A "welcome home" float was a feature of the July 4, 1919, parade. The float is on Main Street near the current location of Woodlands Credit Union. A "welcome home" parade was held on September 29, 1946, in which a large contingent of local citizens who served in World War II in every branch of the military marched.

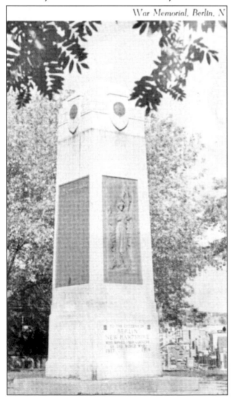

In a downpour, about 6,000 people attended the dedication of the monument to veterans of World War I in Depot Square on July 19, 1921. Speaking was Maj. Gen. Clarence B. Edwards, the commanding officer of the 26th Division. A handful of Civil War veterans unveiled the monument bearing the names of the men from Berlin who served in World War I with an asterisk next to the names of those who died.

Four

Churches and Schools

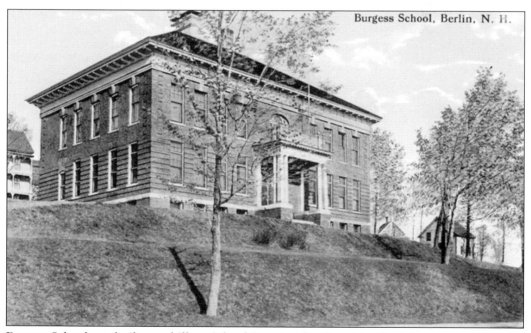

Burgess School was built on a hill on School Street at the site of the first high school in Berlin, which was constructed in 1885 and burned on December 15, 1904. Burgess School was erected in 1906 as a middle school and named for George E. Burgess, for whom the fountain in Post Office Square was also named. Before his death, he funded a night school to teach the immigrants English. Burgess School closed during the Depression and then served as a food pantry and space for Works Progress Administration stitchers. It was bought by Guardian Angel parish and became the Catholic Notre Dame High School, which opened in 1942. Additions were built to the north, including a gymnasium, and to the south, including living quarters for the nuns. It closed in 1972. The school was used for a time in the 1970s as a public school for fifth and sixth graders, but it closed for good in the early 1980s.

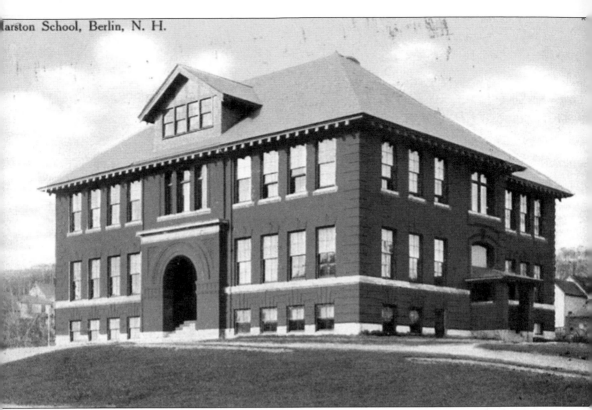

Marston School has always stood on this site on Willard Street. The original wooden structure was erected in 1898. It burned on February 2, 1906, with no loss of life. The elementary school was rebuilt the same year, this time of brick. In 1897, it was named for Henry Marston, the first mayor of Berlin, and is still in use as a kindergarten.

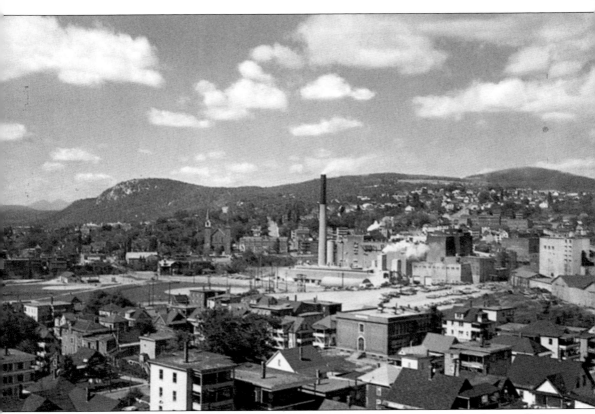

The square building in the center of this card is King School. The only public school on Berlin's East Side was named for mayor Eli King (née Roy) who was in office at the time. The number four fire station was housed on the lower level. The school opened in 1928 and closed in 1971, with the fire station closing in 1979. Today this is the location for St. Vincent de Paul Society's thrift shop. (Courtesy Raymond Daigle.)

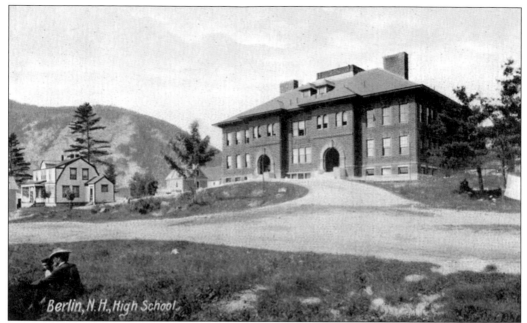

After the first high school burned on School Street, a building committee decided to more centrally locate the next one on Hillside Avenue between High and Willard Streets, as the population of Berlin had quadrupled from 1885 to 1904. Classes were held at the Central Fire Station until the building was completed in the fall of 1906. It had two entrances: one each for the boys and the girls.

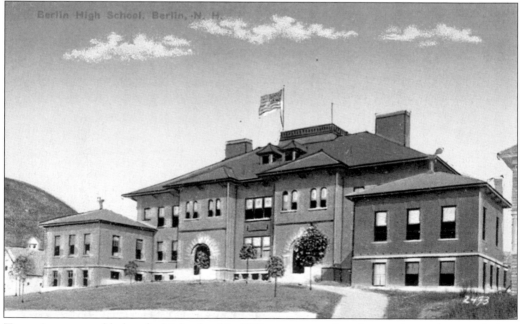

Two wings were added to the high school in 1910 to accommodate the ever increasing population. At this time, Berlin was the third largest city in New Hampshire. When another high school was built in 1922, this building became the Berlin Junior High School. It burned in March 1923 with no injuries resulting as the school was closed for Easter recess.

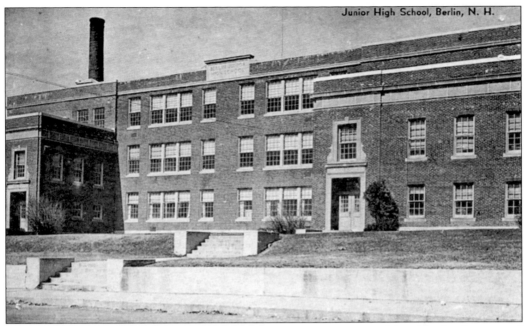

The new Berlin Junior High school was opened in 1926 on the site of the old school. It served as a junior high school until 1972 when it became a middle school. Currently, it is Hillside Elementary School, serving pupils in the fourth grade from all over the city, thus freeing up space in the public grammar schools for pupils from the Catholic schools that have closed.

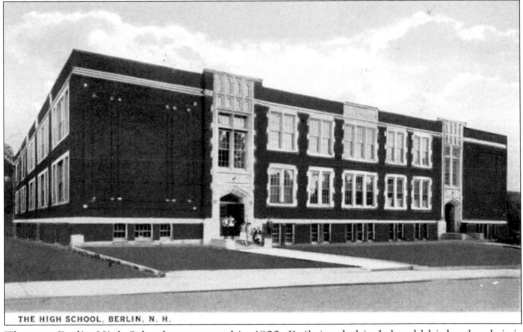

THE HIGH SCHOOL, BERLIN, N. H.

The new Berlin High School was opened in 1922. Built just behind the old high school, it is located on State Street between High and Willard Streets. It has a spacious auditorium that is often used for nonschool-related functions. This high school has a gymnasium with an overhead running track.

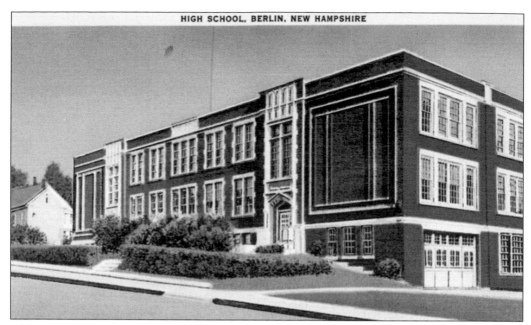

The addition of a new, larger gymnasium with spectator seating connected the junior and senior high schools and necessitated the closing of the northern end of Pine Street, which now ends as a driveway between Marston School and the former junior high. This high school was replaced by a new school in 1972, which was built at the end of Willard Street. It is now the junior high/middle school.

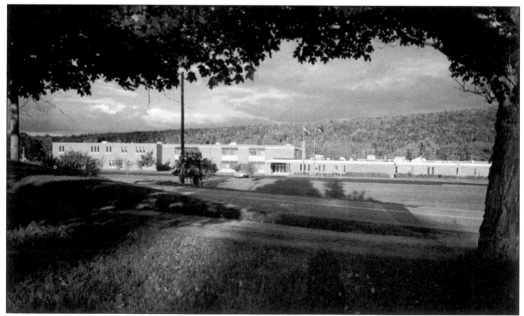

The first post–secondary school in Berlin was the Berlin Vocational-Technical College. Opened in 1966, it was built north of the downtown on land donated by the family of Mark Twitchell. His former home, located across Route 16 from the school, now serves as the administration building. The school has expanded several times over the years, and its name has changed. Today it is known as White Mountains Community College.

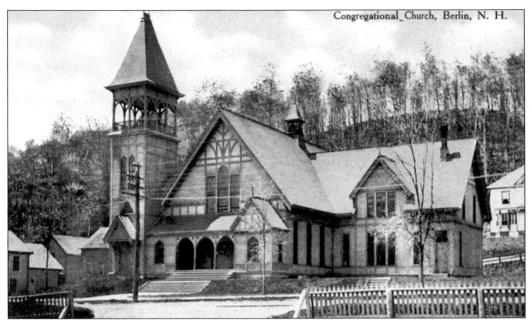

The Congregational society was organized under the name Parish of the Church of Christ on June 27, 1881. William Wentworth Brown, owner of the Berlin Mills Company, donated the land for the church across the street from his sawmill on Main Street north of the downtown. It was dedicated on July 22, 1883. This was the first church building in Berlin and is on the National Register of Historic Places.

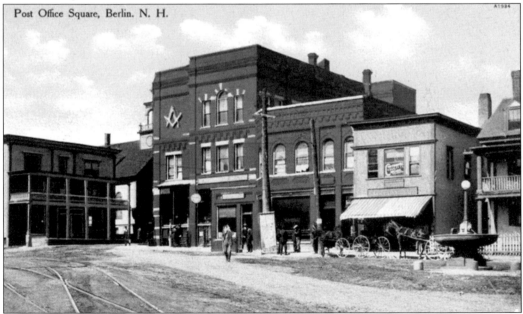

Post Office Square, Berlin. N. H.

The Universalist church, barely visible, was erected on Exchange Street in 1887 on land donated by Daniel Green. From 1894 to 1897 no Universalist services were held, but the church was occupied first by the Episcopalians, then by the Methodists, and later by the Baptists until their own churches were built. Universalist services resumed in 1897. The building was sold in 1918 to become the Jewish synagogue. Currently it is the Heritage Baptist Church.

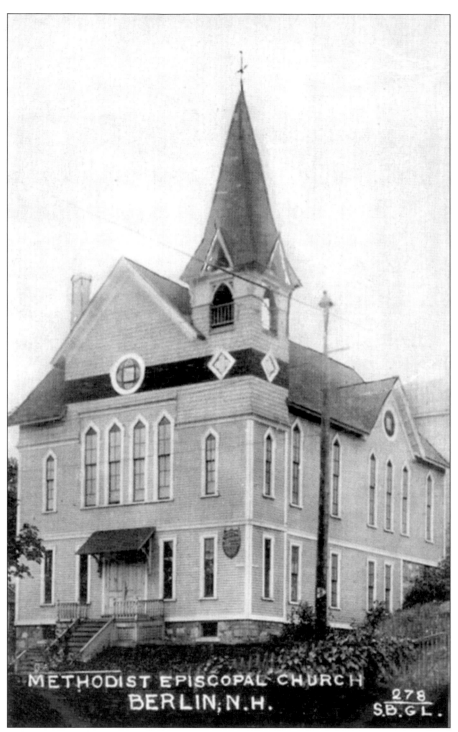

METHODIST EPISCOPAL CHURCH
BERLIN, N.H.

278
S.B.G L.

The Methodist church on the corner of Mount Forist Street and First Avenue, erected on land donated by the Green Land and Aqueduct Company, was dedicated in 1895. The building still stands and serves as the Seventh-Day Adventist church. The Methodists currently share space with the Congregationalists at the United Church of Christ on upper Main Street.

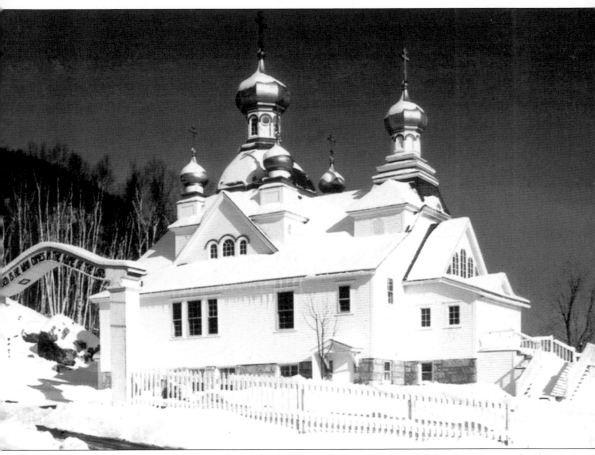

The Russian Orthodox Church of the Holy Resurrection was dedicated in 1915. It was built in traditional Russian style with six onion-shaped cupolas and eight crosses. Its icons are some of the last ones allowed to leave Russia by Czar Nicholas II before he was overthrown. Closed from 1963 to 1974, services resumed in English instead of Church Slavonic, as had previously been the case. This church is also on the National Register of Historic Places.

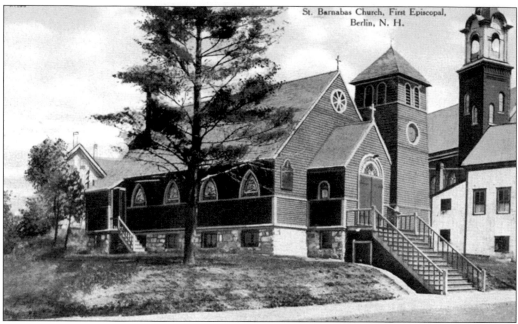

The original wooden building of St. Barnabas Episcopal Church and the land where it was constructed at the corner of Main and High Streets were donated by Henry Hart Furbish, owner of the Forest Fibre Company, who lived across the street. The edifice was consecrated in 1889. The first pipe organ in Berlin was installed in this building in 1893.

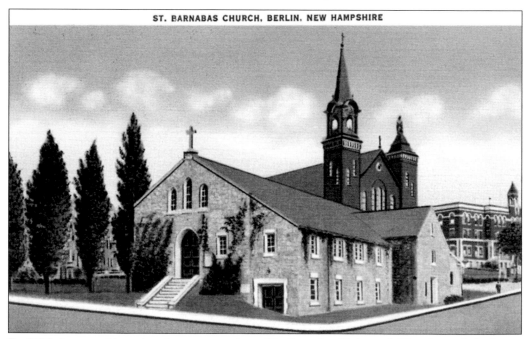

By 1929, it was evident that the congregation of St. Barnabas Episcopal Church needed a larger building. The cornerstone for the current church was laid that year. The main entrance was moved from Main Street to High Street. The original altar in this new church was destroyed by arson on April 17, 1957.

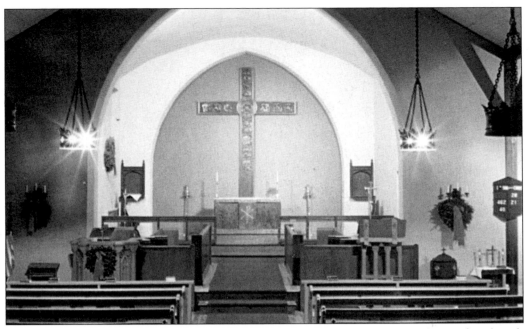

Acclaimed local artist and part-time architect Robert Hughes oversaw repairs to the church and constructed a 14-foot cross of teakwood for the altar. It features a carved head of Christ and the heads of his 12 apostles. An open house was held at the church on October 20, 1957, just six months after the destruction of the altar.

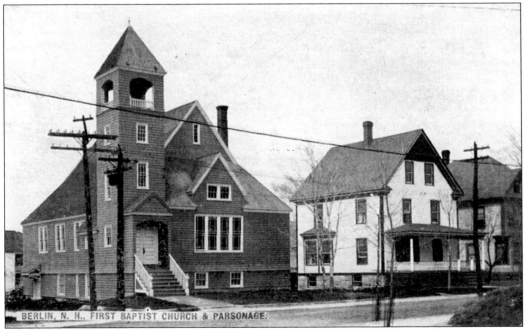

BERLIN, N. H., FIRST BAPTIST CHURCH & PARSONAGE.

The first Baptist service in Berlin was held on Sunday, January 25, 1895, in the Universalist church. A suitable building site for the congregation's own church was found in 1898 on the corner of High and School Streets. The First Baptist Church was dedicated in September 1900. The parsonage is located next to the church.

The catholic parish and its parochial school on the East Side were named Guardian Angel. The parish is most closely associated with Msgr. Omer F. Bousquet, who ruled the East Side like a secondary mayor from 1921 to 1958. The parochial school opened in 1918 and closed in 1981 as Catholic East. The church closed with the other catholic churches in 2000. It is now a Baptist church.

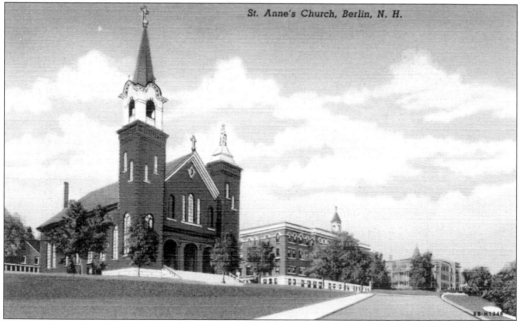

From left to right at the northerly convergence of Pleasant and Main Street where one-way travel ends in the downtown area are St. Anne Roman Catholic Church on the corner of Church Street; St. Regis Academy, the parochial school for St. Anne; and St. Louis Hospital, originally built by St. Anne. Both the school and the hospital are now elderly housing facilities.

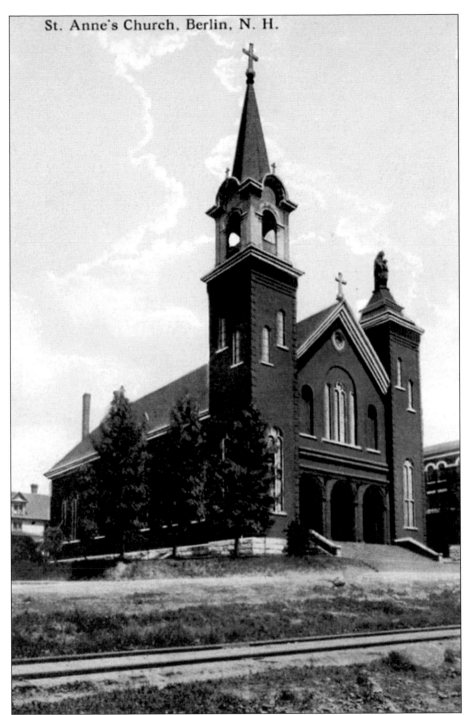

St. Anne's Church, Berlin, N. H.

St. Anne Roman Catholic Church is the largest church in Berlin and the first Catholic parish in the city. A wooden church was built in 1885 at the corner of Pleasant and Church Streets. The parish soon outgrew this building. In 1889, the wooden structure was moved to an area behind St. Regis Academy to allow for construction of a larger church. The new brick church, begun in 1899, was completed in 1909.

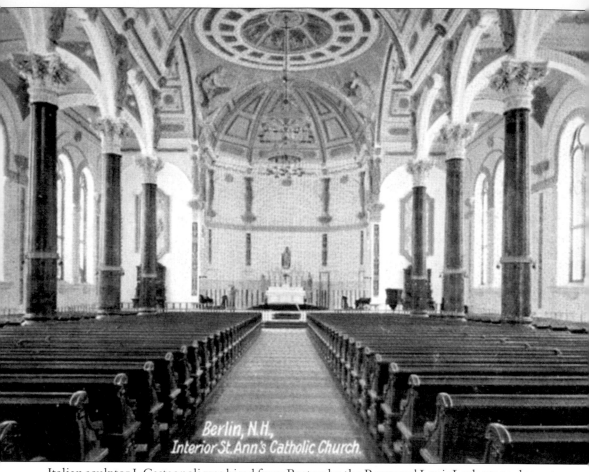

Berlin, N.H., Interior St. Ann's Catholic Church.

Italian sculptor J. Castagnoli was hired from Boston by the Reverend Louis Laplante to decorate the interior of St. Anne Roman Catholic Church. It is finished in white and gold with the ceiling in old ivory. A wainscoting of white Vermont marble encircles the interior. The pillars are of Sienna marble. The first mass was celebrated on May 6, 1901. (Courtesy Raymond Daigle.)

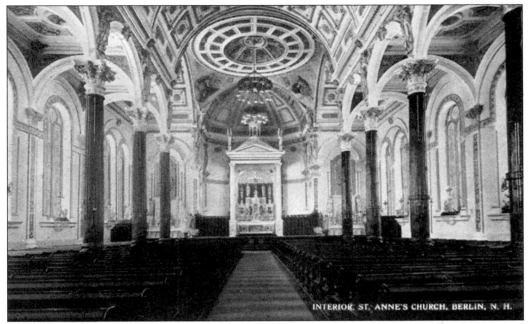

By 1909, the main altar, a gift of the children of St. Regis Academy, was in place. The church was equipped with a Casavant organ from Canada, and the bells were from Hildebrand in Louviers, France. Bishop George A. Guertin of Manchester attended the dedication ceremony on August 25, 1909. St. Anne had about 6,000 parishioners at this time. (Courtesy Raymond Daigle.)

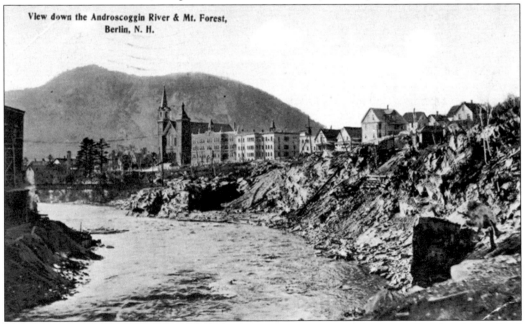

St. Anne Roman Catholic Church closed on October 28, 2000, and reopened as Good Shepherd parish. The church building retained the name St. Anne and is the only Roman Catholic church to remain open in Berlin after the consolidation of the parishes in 2000. St. Anne Roman Catholic Church is the last of the three churches in Berlin on the National Register of Historic Places. (Courtesy Raymond Daigle.)

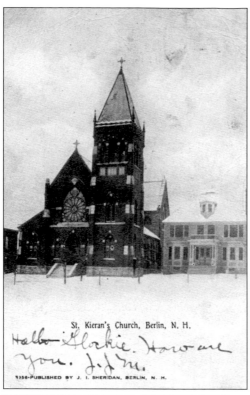

The congregation at St. Anne Roman Catholic Church was becoming so large that the English-speaking parishioners of the French-Canadian parish petitioned Bishop Denis M. Bradley in 1894 to establish their own parish. The petition was granted, and the Reverend Edward D. Mackey was sent to see to this new parish. There were 91 families and 679 members. Land was secured on the corner of Emery and Willard Streets.

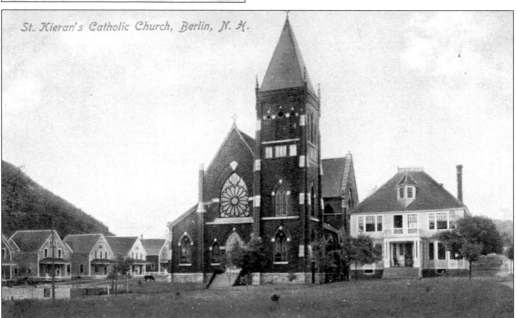

St. Kieran Church was dedicated in May 1895. A house was built at the same time next to the church to be used as the rectory. A brick rectory was built around the corner on Madison Avenue in 1907. The original rectory was then used by the Sisters of Mercy as their convent. Father Mackey purchased land on Madison Avenue and had a series of houses built, which became known as Mackeyville.

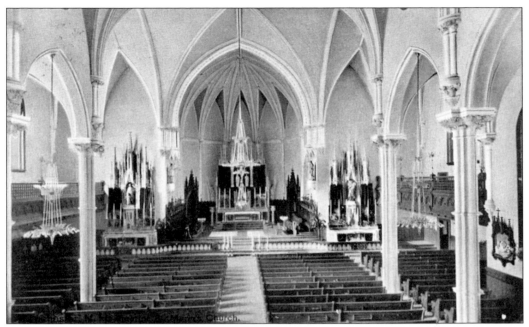

An organ from the Hook and Hastings Company of Boston was installed in 1899. The first ski mass in the country was held at St. Kieran Church in 1936. Skiers and their equipment filled the church. St. Kieran, along with the other Catholic churches in Berlin, closed in 2000. It is currently the St. Kieran Community Center for the Arts. (Courtesy Raymond Daigle.)

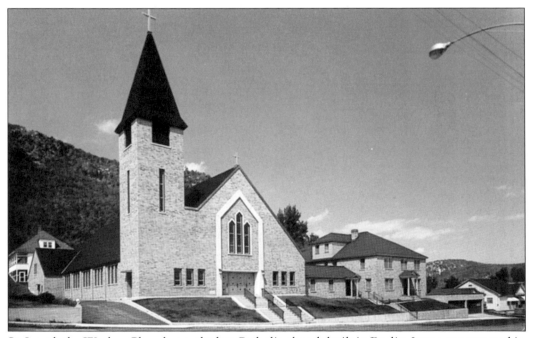

St. Joseph the Worker Church was the last Catholic church built in Berlin. It was constructed in 1958 on Third Avenue across the street from St. Joseph School. The nuns and the parishioners in this area used the chapel in the basement of the school for services and sacraments until the church was finally built. This church closed with the other Catholic churches in 2000.

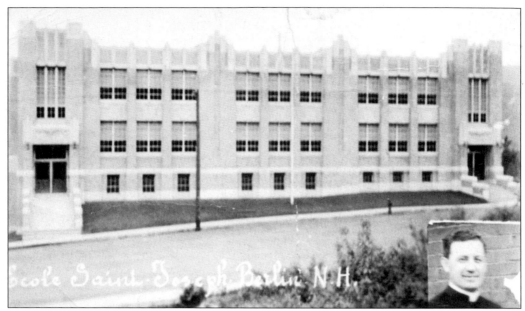

St. Joseph School was built in 1930 to accommodate the students from the Avenues section of Berlin and to relieve overcrowding at St. Regis Academy. The teachers were French-Canadian Sisters of the Presentation of Mary from Quebec, the same as at St. Regis. The school closed in 1971. Pictured is Rev. Msgr. Alpherie Lauziere, who served as pastor from 1941 to 1967.

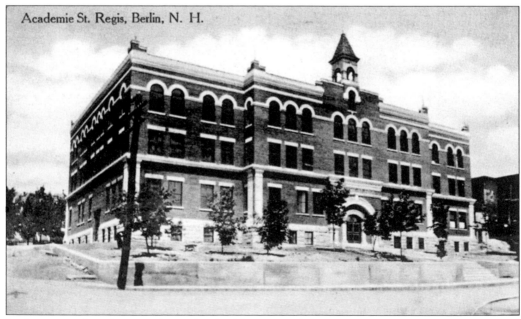

St. Regis Academy's original wooden building began life as the Whirling Eddy House, a hotel owned by Henry F. Marston, later the first mayor of the city of Berlin. It was called the Cascade House when it was sold in 1888 to the Reverend Narcisse Cournoyer, pastor of St. Anne Roman Catholic Church, for use as an elementary school. The school opened on September 15, 1889, with 400 students.

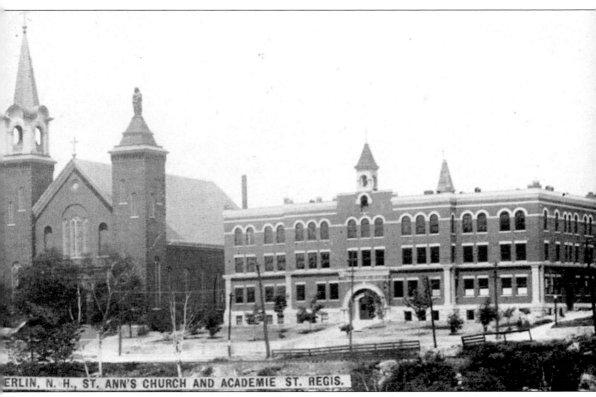

ERLIN, N. H., ST. ANN'S CHURCH AND ACADEMIE ST. REGIS.

When the original St. Anne's was moved to build a larger church, it was used for classes for the lower grades. The old church steeple can be seen behind the school. In 1909, there were 1,300 students, necessitating a larger school. The current brick building was built in 1911. One-third of the old school was attached to St. Louis Hospital as an expansion. It served as a Catholic junior high for two years until it closed 1973.

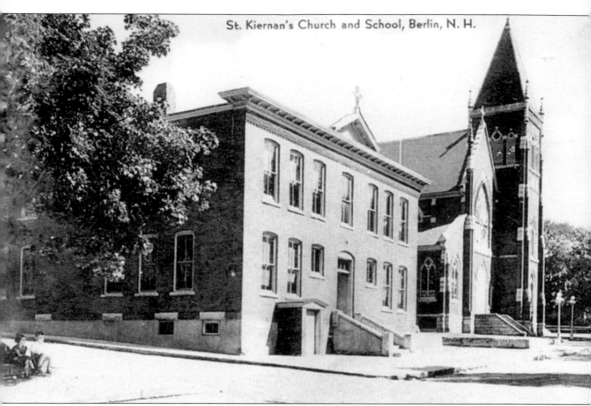

St. Kiernan's Church and School, Berlin, N. H.

St. Patrick Grammar School was built by St. Kieran Church in 1903 on the corner of Emery Street and Madison Avenue, which was Hemlock Street at that time. The original enrollment had 110 students. The first nuns who taught here were Irish Sisters of the Presentation of Mary from Massachusetts. In 1911, the Sisters of Mercy took over the teaching of the students at the school and moved into the newly vacated former rectory.

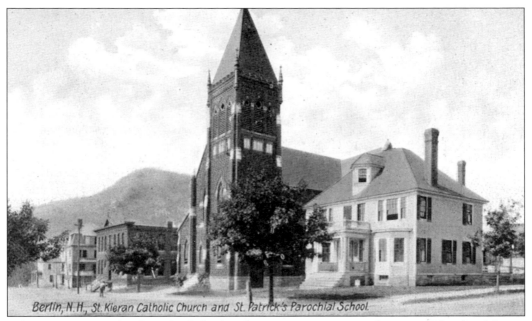

Berlin, N.H., St. Kieran Catholic Church and St. Patrick's Parochial School.

A larger grammar school was built further down Emery Street on the corner Blanchard Street just one block beyond what is visible on this postcard. The old elementary school became St. Patrick High School in 1949 and remained open until 1964. The students were dispersed between Notre Dame and Berlin High Schools. This school building is now St. Kieran House, which accommodates the Good Shepherd parish office and boarders.

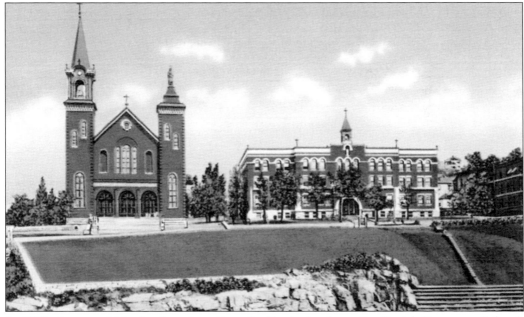

In 1973, the parochial school students from St. Regis Academy, St. Patrick Grammar School, and St. Joseph School combined at St. Patrick's to form Catholic West, with Guardian Angel School becoming Catholic East. All Catholic school students in Berlin merged to form Berlin Regional Catholic School at the former St. Patrick's in 1981. It was renamed St. Michael School in 1997. This last Catholic school closed in 2007.

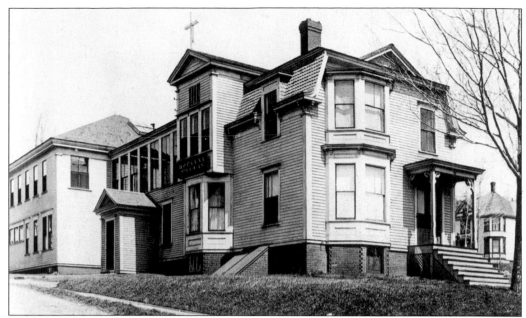

A hospital was established on the corner of Main and Success Streets by St. Anne Roman Catholic Church in 1905. It was named St. Louis Hospital in honor of the pastor, the Reverend Louis Laplante. Four Sisters of Charity from St. Hyacinth in Quebec, Canada, came to Berlin to staff the new hospital. The original house can still be distinguished in this photograph. Note the first of four additions on the left.

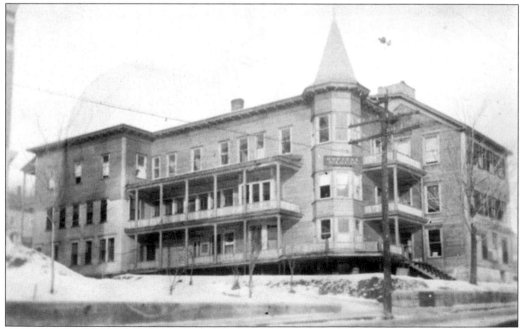

The nuns purchased the hospital from the parish in 1909 for $1,000. This postcard shows the building after the addition of one-third of the Cascade House in 1911, when the brick St. Regis Academy was built. The hospital was now forever changed from its origin as a single-family house. Bed capacity increased accordingly from 15 beds to 63 beds.

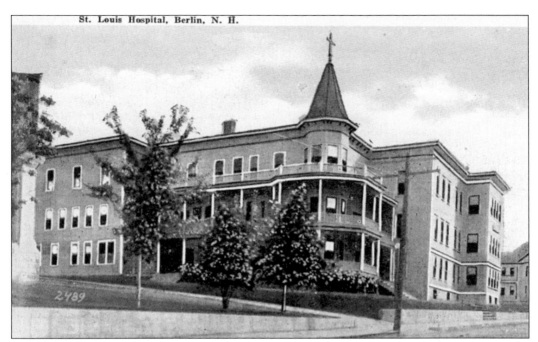

St. Louis Hospital, Berlin, N. H.

2489

This is how the hospital looked in 1939 after its third addition, which included an elevator across the hall from the emergency room. The number of beds was now 75. The Sisters of Charity, or Grey Nuns, as they were known, lived within the hospital. They even had their own chapel, which was on the second floor. The hospital now extended to School Street. (Courtesy Raymond Daigle.)

The fourth and final addition was built in 1954. An elevator was incorporated into this addition to carry patients and visitors, as there was no segregation despite having two elevators. The main entrance was now on School Street and the front stairs were removed. The capacity was 129 beds. From this view, the first-floor lobby, second-floor medical and surgical area, third-floor operating and recovery rooms, and fourth-floor pediatrics can be seen.

The hospital ended its affiliation with the Sisters of Charity to become a not-for-profit lay organization in 1971. The name was changed from St. Louis Hospital to Androscoggin Valley Hospital to reflect this. In 1978, a larger, more modern facility was built 1.5 miles north on the outskirts of Berlin on the other side of the river directly across the Twelfth Street bridge at 59 Page Hill Road.

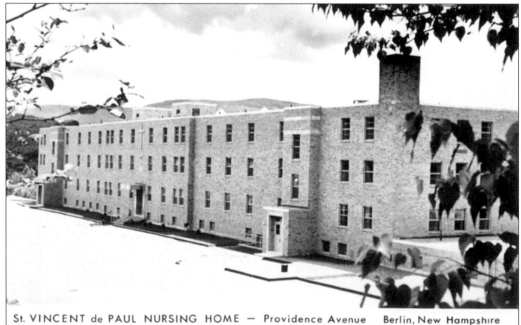

St. VINCENT de PAUL NURSING HOME — Providence Avenue Berlin, New Hampshire

St. Vincent de Paul, the first nursing home in Berlin, was built in 1962 by the Sisters of Providence on Patten Avenue. The name of the street was changed to Providence Avenue to reflect its most prominent structure. St. Vincent de Paul is now also a rehabilitation facility and is run locally by a secular staff but is still officially owned by the sisters.

Five

INDUSTRY, MILLS, AND LOGGING CAMPS

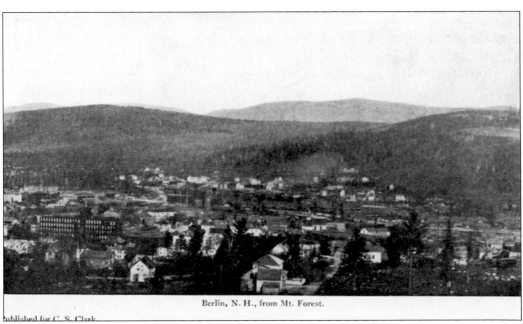

Berlin, N. H., from Mt. Forest.

The large building seen in the lower left was the Berlin Shoe Factory, also called Chick Brothers Shoe Company. It was built in 1896 on the southerly side of Green Street adjacent to the railroad tracks. This was to provide work for women to augment the income of working-class families. New factories opening in the west doomed this venture, and it closed in the early 1900s. (Courtesy Raymond Daigle.)

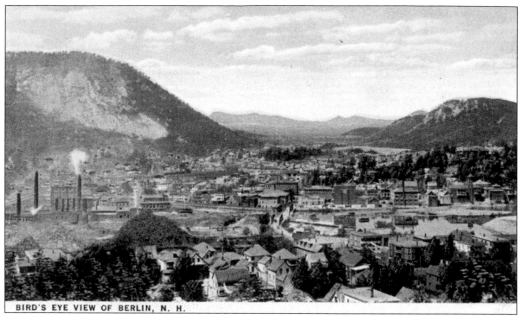

BIRD'S EYE VIEW OF BERLIN, N. H.

In 1946, Converse Rubber Company, Granite State Division, opened a shoe-stitching plant on Wight Street in the former Lemieux Furniture factory building. In 1956, the company expanded, adding a new plant on Jericho Road that now made the entire shoe, including the famous Converse All Star. The shoe plant closed as Bass Shoe around 1984. At one time, these two plants employed over 1,000 people. (Courtesy Raymond Daigle.)

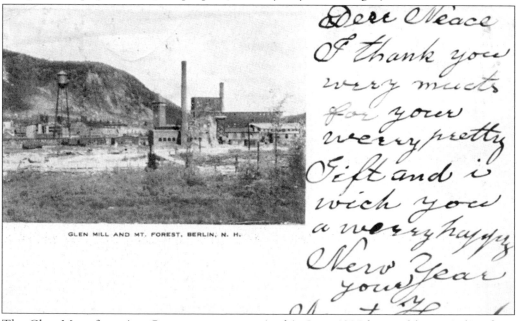

GLEN MILL AND MT. FOREST. BERLIN. N. H.

The Glen Manufacturing Company was organized in June 1885 by wealthy capitalists from Massachusetts. They purchased the "Great Pitch" water privilege of Daniel Green on the Androscoggin River. Construction of the mill began on July 4, 1885, and operations started on May 1, 1886. In 1887, Glen Manufacturing bought the White Mountain Pulp and Paper Company, which was begun in 1883 at the mouth of the Dead River near the Glen mills.

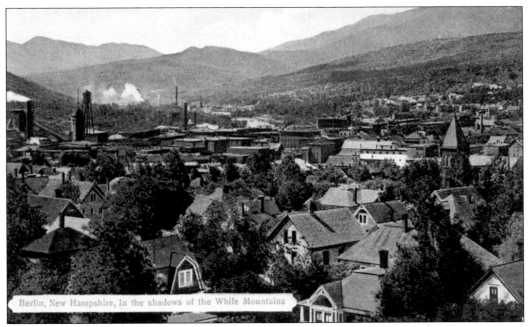

Berlin, New Hampshire, In the shadows of the White Mountains

The Glen Manufacturing Company had 200 employees. In 1886, seven double tenements were built by the company near their time office; the last of these was demolished by Public Service of New Hampshire in 1946. The street that these buildings formed is still called Glen Avenue and is the entrance to Berlin from the south. (Courtesy Raymond Daigle.)

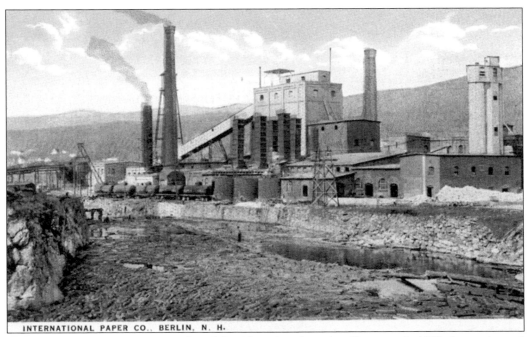

INTERNATIONAL PAPER CO., BERLIN, N. H.

International Paper Company purchased the Glen Manufacturing Company in 1898. It was situated at the southerly end of downtown Berlin where the Dead River flows into the Androscoggin River, thus enabling it to accept logs floating down either river. The old Glen Manufacturing Company mills became the Glen Mill of International Paper.

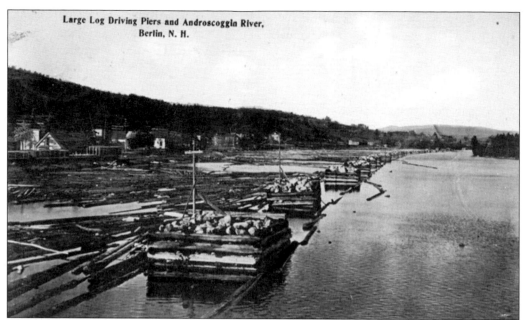

International Paper Company and Brown Company shared the Androscoggin River, so piers, connected with floating logs called booms, were constructed to divide the river in half. The pulp logs were stamped for identification and coaxed to their correct side of the river at the sorting gap in Milan, north of Berlin. Some boom piers still survive today, although all are deteriorating. (Courtesy Raymond Daigle.)

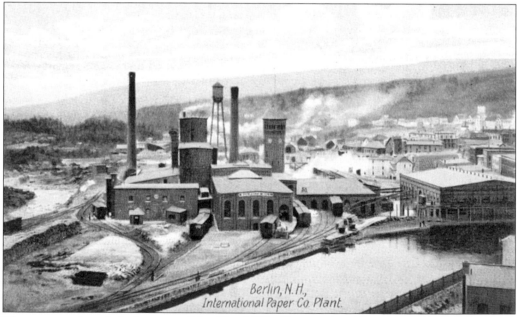

The water tank and clock tower of the Glen Mill of International Paper were distinctive visual landmarks at the time. International Paper closed its Berlin operation in 1930 after a long, rancorous labor strike that almost necessitated intervention by the governor. The mill was completely dismantled soon after. Foundations of some of this mill complex are still visible today along the river walk created by Public Service of New Hampshire.

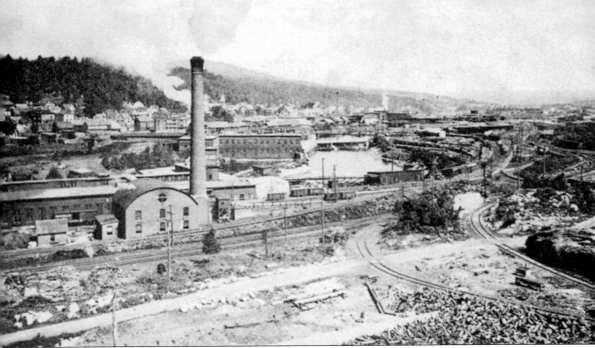

The illustrious Brown Company started as the Hezekiah Winslow sawmill in 1852. The Brown Company House was built across the street in 1853 to accommodate workers. In 1866, Winslow sold out his interest and the name Berlin Mills Company was adopted. William Wentworth Brown of Portland bought controlling interest in 1880. At one point, it became the largest lumber mill in New England, employing 1,000 men.

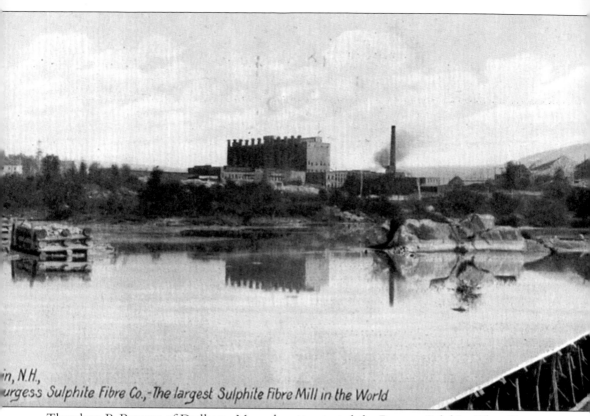

in, N.H.,
urgess Sulphite Fibre Co.,-The largest Sulphite Fibre Mill in the World

Theodore P. Burgess of Dedham, Massachusetts, started the Burgess Sulphite Fibre Company in 1893 with Berlin Mills Company owning the other half of the stock. Berlin Mills Company bought out Burgess Sulphite Fibre Company in 1908. The sulphur method for digesting pulp, developed by Burgess, was more efficient than the soda process used at the Forest Fibre Company. (Courtesy Raymond Daigle.)

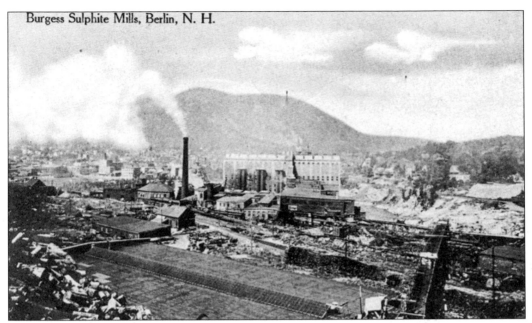

Burgess Sulphite Mills, Berlin, N. H.

At this time, it produced the largest amount of chemical pulp in the world at 400 tons per day. The next largest mill was in Germany. Berlin Mills Company product was transported to almost all paper mills east of the Mississippi River via both the Grand Trunk Railway and the Boston and Maine Railroad. The Grand Trunk Railway tracks were laid to Berlin the same year that the sawmill was built, which was not a coincidence.

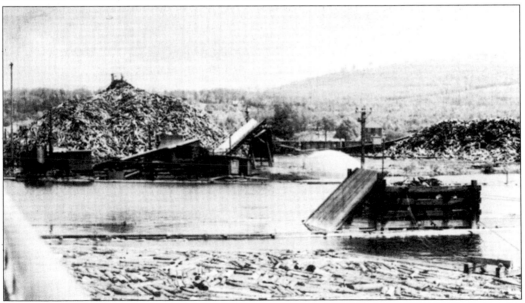

During World War I, goods arriving to other business concerns throughout the United States did not approve of anything stamped "Berlin" as it had connotations of the German capital. In 1917, the Berlin Mills Company changed its name to Brown Company to reflect the familial nature of the corporation. Burgess Sulphite Fibre Company became the Burgess Mill of the Brown Company. The company's holdings in Canada became part of Brown Corporation. (Courtesy Raymond Daigle.)

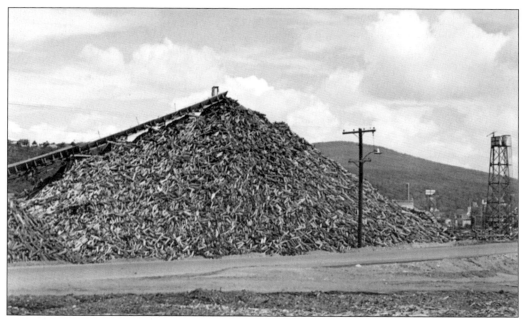

The four-foot pulp logs cut in the northern forests were floated down the river in the days before the roads were passable, and even for a time afterwards. Once they reached their destination, they were coaxed with pick poles onto a conveyer system that carried them onto a very large log pile, some containing 50,000 cords or more.

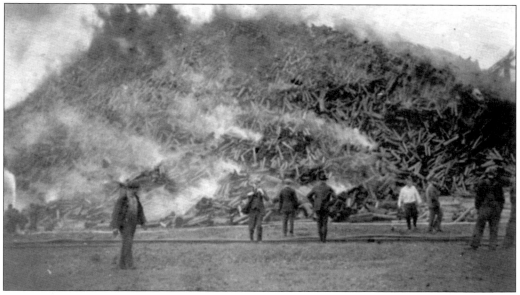

These log piles, known as quarry piles, were utilized as needed. The logs were debarked in barker drums, chipped, and then some of the chips were stored again in large piles. The log piles were carefully monitored and kept wet throughout the summer, as fires sometimes broke out in them. (Courtesy Raymond Daigle.)

A landmark in Berlin for 60 years, the smokestack of the Kraft pulp mill was built in 1947. At 250 feet high, it was visible as far as Cascade in Gorham. It was the lone sentinel until other similarly tall chimneys were built in the 1980s. The mill complex in Berlin, which closed in May 2006, was bought by North American Dismantling and torn down for salvage in 2007.

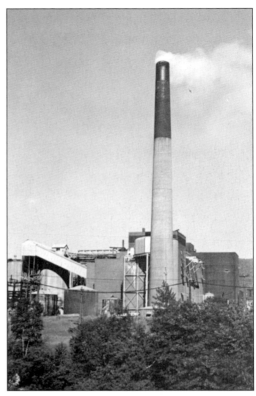

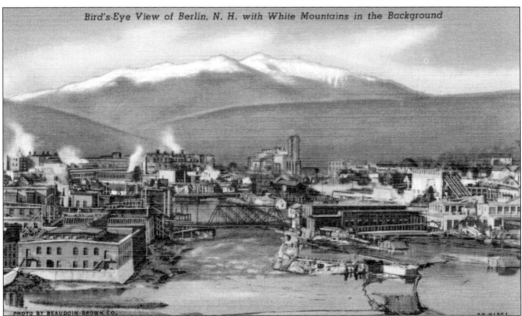

Bird's-Eye View of Berlin, N. H. with White Mountains in the Background

This photograph was taken by Victor Beaudoin, the man most associated with photographs of Brown Company operations and products. In his life, he took about 10,000 pictures, the majority of which are now housed at Plymouth State University. He joined the company in 1926 as staff photographer. Besides photographs, his department also made photostatic copies and educational movies, especially for the woods department.

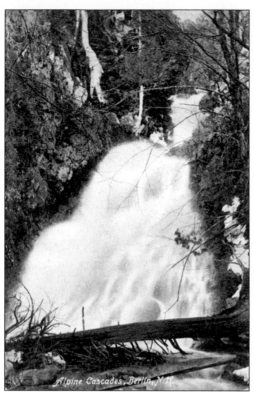

Alpine Cascades is located at the most northerly point in Gorham near the town line of Berlin. The cascades of a brook flowing into the Androscoggin River from the east were an early tourist attraction with a hotel to cater to guests viewing its natural beauty. This section of Gorham, both Cascade Flat near the mill and river and Cascade Hill derived their names from the Alpine Cascades.

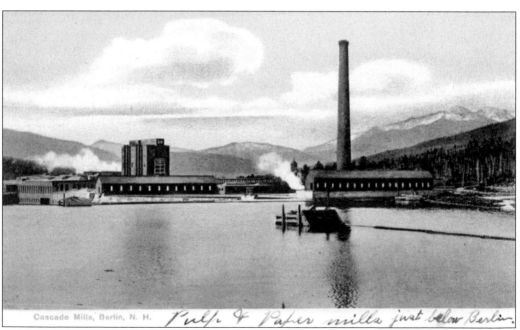

Work was begun on a new paper mill and power dam in the Cascade section of Gorham in 1902. The Cascade mill had the tallest smokestack in New England when it was completed in 1903. The stack stood 230 feet. This was the largest self-contained mill, making both pulp and paper in one plant. It was here that the well-known Nibroc folded Kraft paper towels were made.

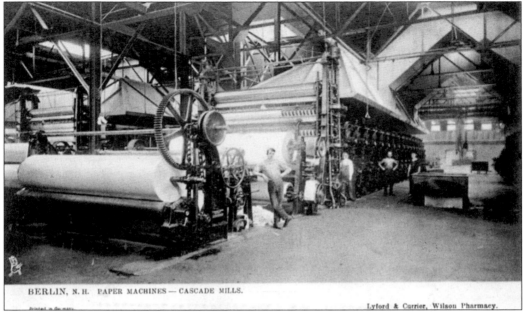

BERLIN, N. H. PAPER MACHINES — CASCADE MILLS.

Lyford & Currier, Wilson Pharmacy.

In 1904, the largest paper machine in the world at that time was started. Plans called for four 164-inch machines. Workers on this immense project were primarily Italian immigrant brick layers who built a small village known as Cascade Flats along the river near the construction. After the Cascade mill was complete, these same workers also built most of the other brick buildings found in Berlin dating from this time.

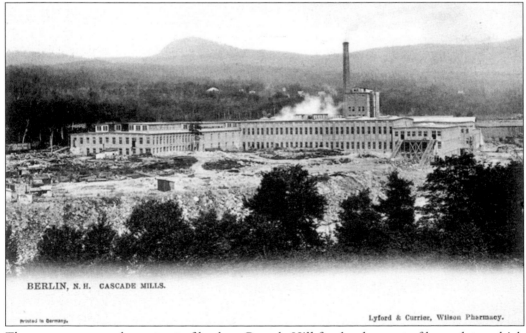

BERLIN, N. H. CASCADE MILLS.

Lyford & Currier, Wilson Pharmacy.

The company opened up a tract of land on Cascade Hill for development of house lots, which can be seen on the hill behind the mill and across Route 16. It was called Woodland Park, although this name is no longer used. Cascade Street is the center street on Cascade Hill and stands exactly on the town line between Berlin and Gorham.

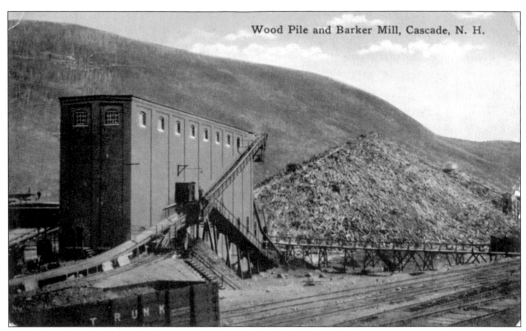

Wood Pile and Barker Mill, Cascade, N. H.

Originally, the Cascade mill had its own wood piles and debarking equipment to produce its own pulp. Goods and chemicals arrived and finished product left the mill complex by railroad via a spur from the Grand Trunk Railway line. The sulphite mill at Cascade closed in 1943 due to lack of pulpwood and a shortage of men. After this, pulp produced at the Berlin mill was piped to the Cascade mill.

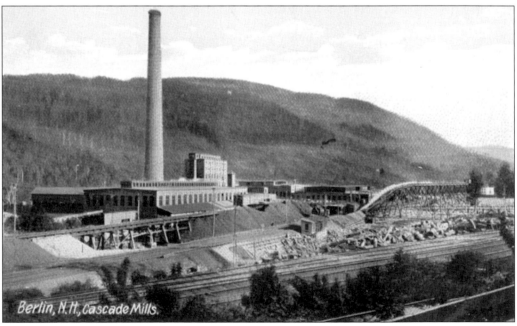

Berlin, N.H., Cascade Mills.

Most of the machines at the Cascade mill were originally operated by coal-fired steam as the electric engines at the time were not very powerful. The piles of coal used to run these machines can be seen in the center adjacent to train tracks that brought it into the mill complex.

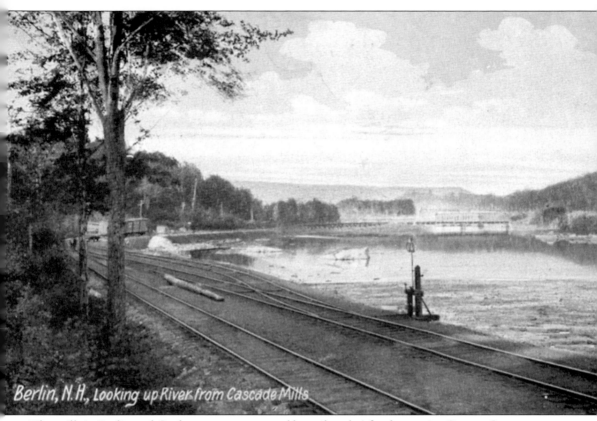

Berlin, N.H., Looking up River from Cascade Mills

The mills in Berlin and Gorham were connected by railroad. After becoming Brown Company, the name Berlin Mills was kept within the complex and used for their railroad. The Berlin Mills Railroad was a vital part of the company. In the 1990s, the railroad was sold to St. Laurence and Atlantic Railroad, and it conducted the railway business within the complex until it closed in 2006.

Brown Company held over 500 patents and employed nearly 100 men in research. It was one of a very few companies that had its own research and development department. This department was headed by Dr. Hugh K. Moore, president of the Institute of Chemical Engineers and winner of the Perkins Medal by unanimous vote. Nibroc towels, Solka Floc, and Bermico pipes were some of the products that Brown Company produced.

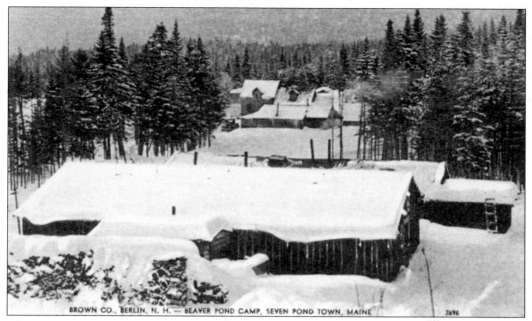

BROWN CO., BERLIN, N. H. — BEAVER POND CAMP, SEVEN POND TOWN, MAINE 2696

The mills at Berlin were in constant need of a good supply of wood to make the pulp that was turned into paper. To this end, the Brown family found it more prudent to own the land that was logged rather than to rely on a middle man. At one time, Brown Company owned 6,900 square miles of timberland across northern New England and parts of Quebec. (Courtesy Raymond Daigle.)

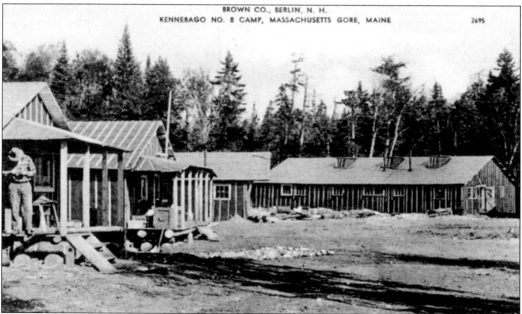

BROWN CO., BERLIN, N. H.
KENNEBAGO NO. 8 CAMP, MASSACHUSETTS GORE, MAINE 2695

Logging camps were established to house the men and horses from autumn to spring when the fruits of their long winter's labor were propelled downstream in the spring freshets. In the early years, this set of camps was built of logs but later were made from rough-hewn lumber covered with tar paper. Some were constructed in panels ready for dismantling and to be moved to the next job.

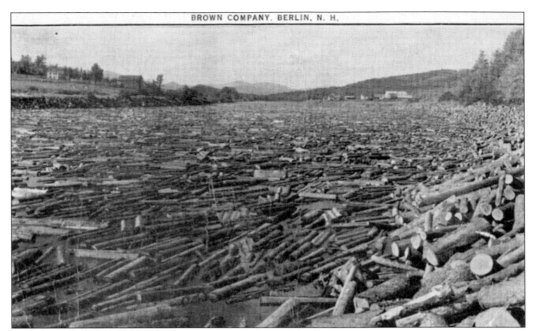

Pulpwood made its way from the small stream to the larger river until they were all floating down the Androscoggin River to Berlin. It was quite a sight every spring to see the river so choked with logs. A person could run across the river to the other side without getting wet. Many young boys tried this, much to the chagrin of their mothers.

BROWN COMPANY WOODS OPERATIONS, BERLIN, N. H.

Life in the woods camps in the 1800s and early 1900s was not easy. Camps were often remote and not easily accessible. Men spent the entire winter there, not returning home until spring, which was ideal work at the time for some farmers. The company had to build roads to provision the camps and, later, bring the wood to a water source.

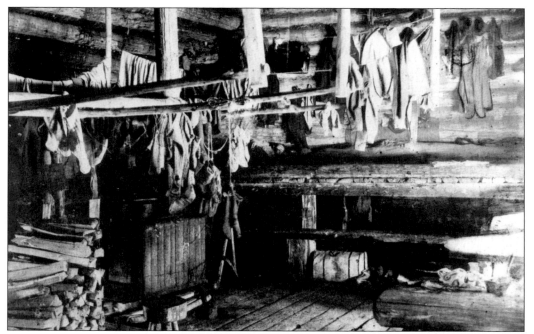

It was an isolated existence with the men living in close quarters, eating, working, and sleeping together. It is said that they did not change their clothes all winter, just hung them up to dry overnight before putting them on again the next morning. Once out of the woods, this clothing was often simply burned.

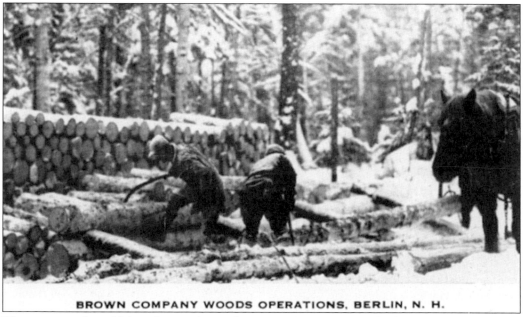

BROWN COMPANY WOODS OPERATIONS, BERLIN, N. H.

The camp cook and his assistant, the cookee, were important in the logging camp because bucking pulpwood on the yard where felled trees were twitched to be cut to length was hard work that burned a lot of calories. The men could consume about 3,000 calories a day and not gain weight. Everything was done by hand until the 1930s and 1940s, when the advent of chainsaws eased the men's labor somewhat.

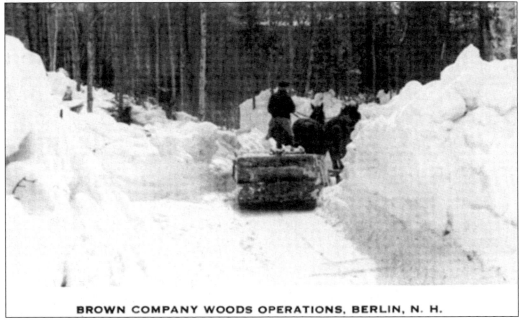

BROWN COMPANY WOODS OPERATIONS, BERLIN, N. H.

Logging was done in the winter to make it easier for the horses to pull the logs down to the wood yard near a stream. There the wood was corded high, awaiting the spring thaw when it could be floated downstream to the mills. A temporary dam was often constructed to build up a head of water, then a pin was pulled and the whole pile tumbled into the stream.

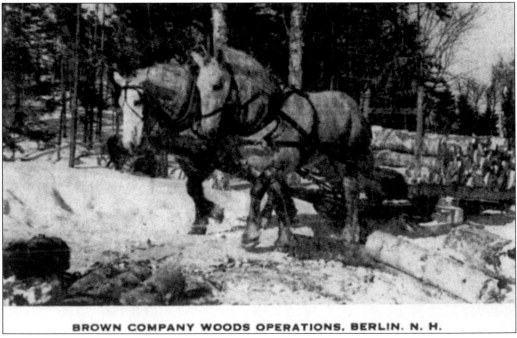

BROWN COMPANY WOODS OPERATIONS, BERLIN. N. H.

Edward Gibbons was hired in Portland in 1881 by William Wentworth Brown. He came to Berlin in 1897 to care for the workhorses used in the logging camps after Dr. Hillier left. Affectionately known as "Doc Gibbons," he traveled from camp to camp tending to the horses. He died in 1942 and is buried in Berlin.

It was John Farrington who kept exact records of each horse. He traveled from camp to camp to record the number of the horse, the weight, the age, and so on. Each spring, the right front hoof was branded, and the left front hoof was branded in the fall. The highest number he ever branded was 928. He also went out West with William Robinson Brown to buy boxcar loads of horses.

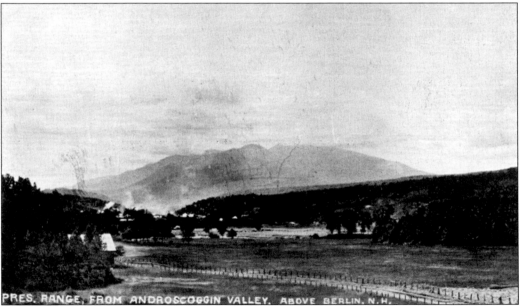

PRES. RANGE, FROM ANDROSCOGGIN VALLEY, ABOVE BERLIN, N. H.

John Farrington died in 1950 at age 83, having been retired from Brown Company "a few months." The peak use of horses by Brown Company was in 1903 after which logging was contracted out more frequently to jobbers. By 1930, Brown Company employed only about 75 horses, although the use of horses continued into the 1940s and early 1950s. Pictured is the view from the Brown Company farm in Berlin. (Courtesy Raymond Daigle.)

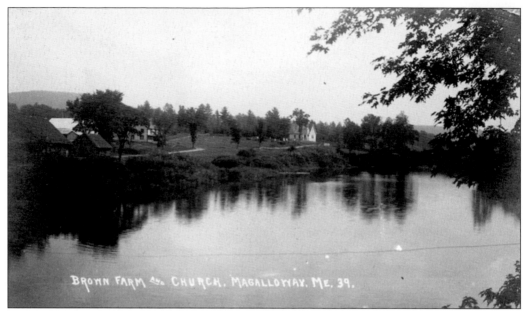

The Brown Company farm in Berlin was not the only farm the company had where workhorses spent the summer or went to recuperate from injury or surgery. There were several scattered throughout the north woods. This farm was just over the border of northern New Hampshire in Magalloway, Maine. After a fire, the farm was moved across the Magalloway River to Wentworth Location. The church still stands.

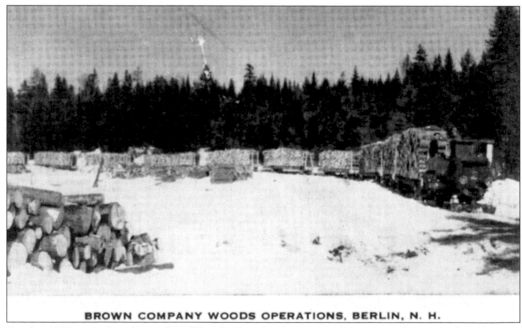

BROWN COMPANY WOODS OPERATIONS, BERLIN, N. H.

By the 1920s, modern inventions like the Lombard Log Hauler, invented in 1900 by Alvin O. Lombard of Maine, were sometimes used to pull as many as 10 sleds of logs weighing as much as 300 tons. There were also logging trains. The Blanchard and Twitchell Railroad brought wood into Berlin from Success, whereas the Millsfield Railroad merely brought the logs out of the woods.

BROWN COMPANY WOODS OPERATIONS, BERLIN, N. H.

As an example, the Brown Company's woods operations in the Parmachenee area in 1955 encompassed 120 square miles. All cutting was confined to areas of mature and over mature timber. Areas of second growth that were not yet mature were left standing for future use. It was one of the largest woods operations in the Northeast. It consisted of four camps and three contractor operations.

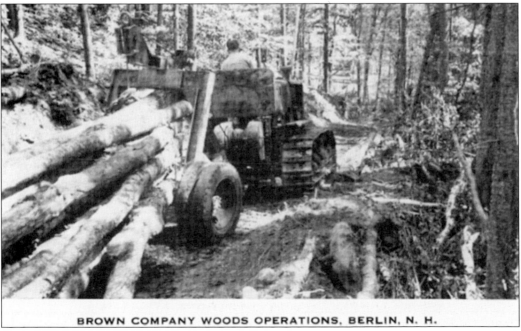

BROWN COMPANY WOODS OPERATIONS, BERLIN, N. H.

The Parmachenee operation maintained a workforce of 175 cutters and 140 support personnel, such as swampers, tractor and crane operators, scalers, clerks, foremen, mechanics, blacksmiths, janitors, cooks, and road maintenance crews. About 100 horses and 16 tractors were needed in this operation. Nearly 75,000 cords of wood were produced that season.

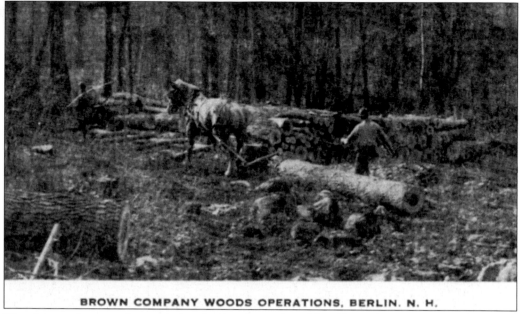

BROWN COMPANY WOODS OPERATIONS, BERLIN, N. H.

The rivers and streams famous in logging lore in northern New Hampshire carry names like Dead Diamond, Swift Diamond, Magalloway, and Clear Stream, all flowing into the Androscoggin River. Clear Stream, near Errol, was where one of the last logging camps was situated. In the end, men could come home for weekends as roads had greatly improved and some camps, like Clear Stream, were nearer to home.

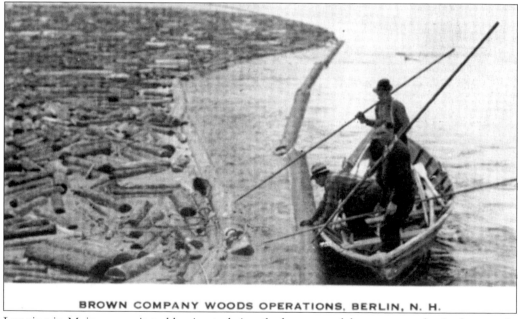

BROWN COMPANY WOODS OPERATIONS, BERLIN, N. H.

Logging in Maine necessitated having to bring the logs across lakes to get to the Androscoggin River. Logs were corralled into a great floating island of 2,500 cords or more, depending on the weather, and towed across lakes by Brown Company's towboats. The wood traveled from Rangeley and Cupsuptic Lakes down Mooselookmeguntic Lake, Richardson Lake, Rapid River, and Lake Umbagog. Here a bateau crew with pick poles tends the booms.

Besides transport over the lakes, the pulpwood also had to be sluiced over one dam after another on the rivers until finally reaching the Androscoggin River. Even then, the logs were not home free. They had to be sluiced one more time over the Pontook Dam on the Androscoggin River in Dummer before finally floating downstream through Milan to Berlin.

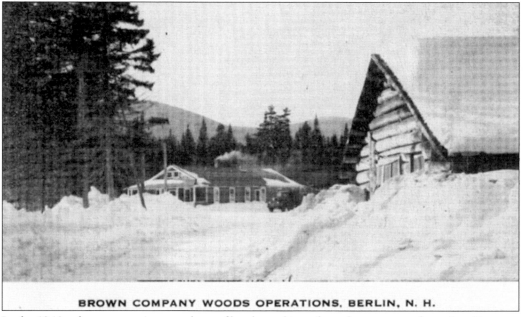

BROWN COMPANY WOODS OPERATIONS, BERLIN, N. H.

In the 1940s, there was an increased use of hardwood in pulp and paper manufacturing. Because hardwood does not float, roads were improved to allow trucks to reach the wood yards. Now pulp wood was delivered directly from yards in the woods to yards at the mill. Mechanical equipment also was introduced in the 1950s, replacing brawn and pulp hooks to load and unload the trucks.

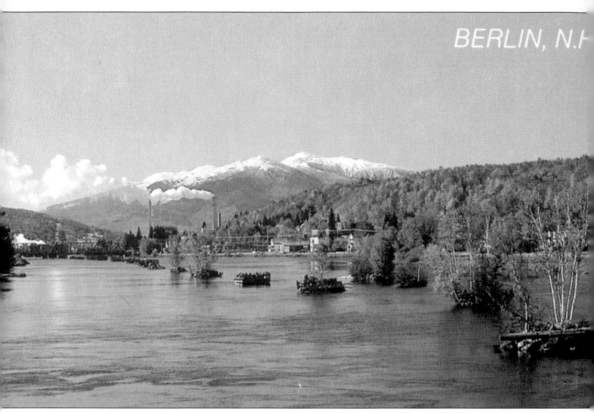

The last log drive to take place down the Androscoggin River to the mills in Berlin was in 1964. There is a historic marker along the river in the north end of the city commemorating the drives and explaining the boom piers, remnants of which are still visible. Every year, Berlin honors the boom piers with RiverFire when fires are lit on the piers one evening in October.

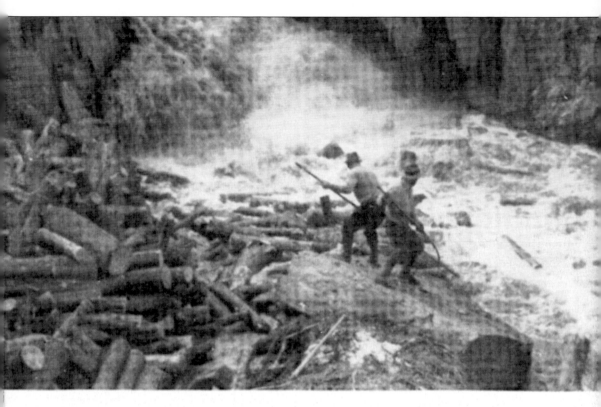

BROWN COMPANY WOODS OPERATIONS, BERLIN, N. H.

This last logging postcard is perhaps the most well-known view of old-time logging in northern New England. Here river drivers demonstrate the skill and outright danger involved in bringing the logs downriver to the mill in the spring. Using pick poles to maneuver the hung up logs into the swift current, these men work the high water in Hell Gate Gorge on the Dead Diamond River in the second Dartmouth College grant in northern New Hampshire.

ACROSS AMERICA, PEOPLE ARE DISCOVERING SOMETHING WONDERFUL. *THEIR HERITAGE.*

Arcadia Publishing is the leading local history publisher in the United States. With more than 3,000 titles in print and hundreds of new titles released every year, Arcadia has extensive specialized experience chronicling the history of communities and celebrating America's hidden stories, bringing to life the people, places, and events from the past. To discover the history of other communities across the nation, please visit:

www.arcadiapublishing.com

Customized search tools allow you to find regional history books about the town where you grew up, the cities where your friends and family live, the town where your parents met, or even that retirement spot you've been dreaming about.